ULTIMATE
FIELD GUIDE TO
TRAVEL
PHOTOGRAPHY

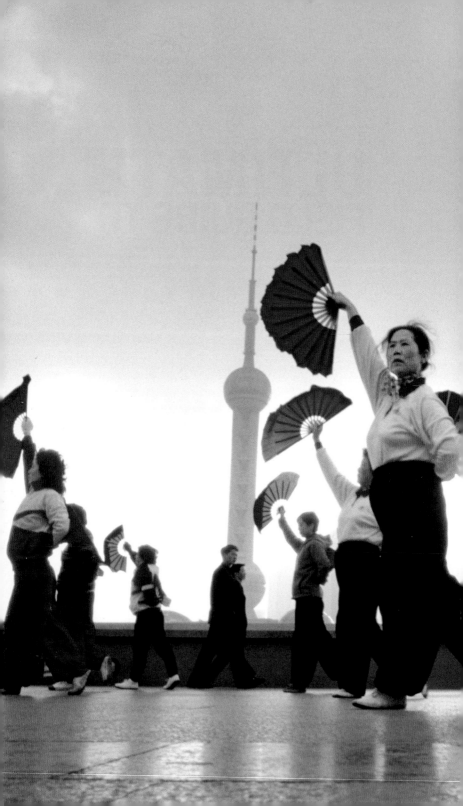

ULTIMATE
FIELD GUIDE TO
TRAVEL
PHOTOGRAPHY

SCOTT S. STUCKEY

 NATIONAL GEOGRAPHIC

WASHINGTON, D.C.

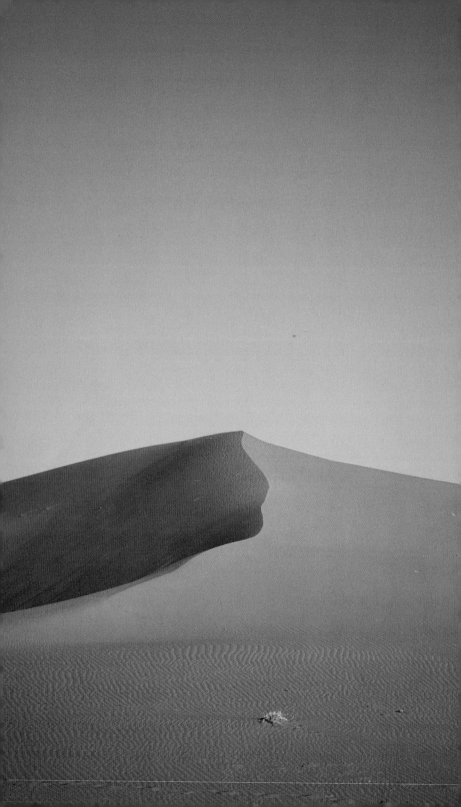

CONTENTS

Shadow and blue sky define the edges of a sand dune in South Africa's Northern Cape province.

Previous pages: Dancers fan out against the skyline of the Pudong district of Shanghai.

On the cover: At Kenya's Masai Mara preserve, a cheetah uses a safari vehicle to help it scan the savannah for prey.

Introduction

At *Traveler* magazine, where I'm the managing editor, we publish travel photography that "puts the readers there," inspiring many of them to go to the places we cover. Often those readers write us letters of thanks, and some marvel at our photography. Implied in their comments, if not stated outright, is a question: "How did your photographer do it?" This book is intended to answer that question.

A big part of the "how," of course, is dogged effort. "The difference between professional photographers and amateurs," notes *Traveler* photographer Macduff Everton, "is that professionals never get to eat their meals at regular times." That's because the breakfast and dinner hours are better spent taking pictures. Everton recalls shooting on the North Rim of the Grand Canyon on a rainy day as dinnertime approached. "It was getting late," he says, "and I was about an hour and a half from the lodge. I had to decide whether to go back before the restaurant closed or gamble that the weather would break." Everton took the gamble—missed dinner—and got to shoot the canyon in the best light he'd ever seen (below).

Another dramatic difference between amateurs and pros is that the pros will work a scene. That is, after

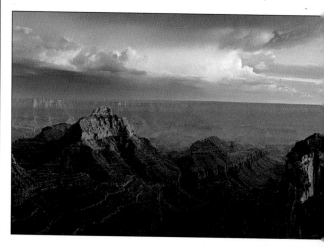

discovering a potentially good shot—say, a lovely couple at a sidewalk café or a Paris skyline viewed from a tower at the Notre Dame Cathedral—they may shoot dozens of pictures, becoming ever more intimate with the nuances of the composition or lighting, adding or subtracting elements, all in the hope of capturing one good picture for publication.

Most photography how-to books are based on the expertise of one photographer—the author. This one is different. In researching this book, I interviewed 15 full-time freelance photographers, whose very bread and butter depends on taking good pictures. So here, in one book, the world's top travel photographers share their know-how, covering basic and advanced techniques, with particular emphasis on specific strategies for shooting different types of destinations.

Each photographer has a distinctive style, proof that there's no one right way to shoot a travel photograph. What *Traveler* photographers do have in common—like most of us when we travel—is a very limited amount of time in the field, usually ten days or less. So they have to focus their efforts and shoot smart.

After reading this book, you'll understand the level of commitment required to be a *National Geographic Traveler* photographer. There's something here for photographers of every skill level, but the book will be of particular interest to those ready to do what it takes to start shooting like the pros.

Scott S. Stuckey

Macduff Everton missed dinner to shoot this remarkably lit composition from the Cape Royal Trail on the North Rim of the Grand Canyon.

Get Inspired

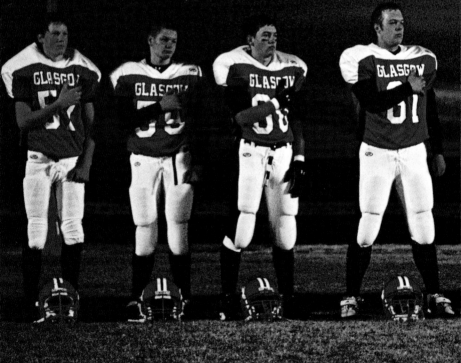

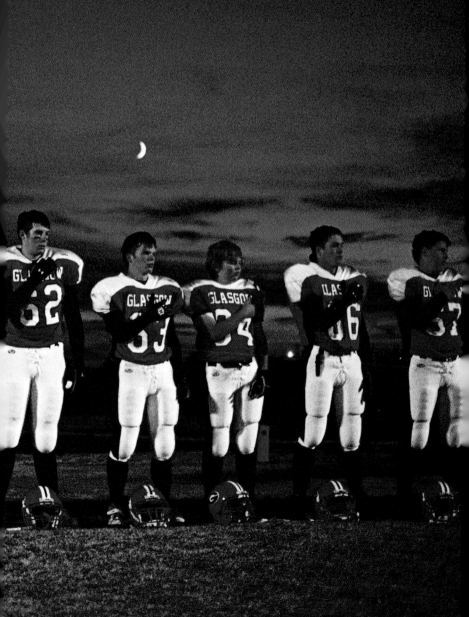

1 *Get Inspired*

Previous pages:
Aaron Huey boldly
walked out onto the
football field to get
this pregame shot of
the home team in
Glasgow, Montana.

Before embarking on your next journey, spend a little time sharpening your photographic eye. "I look at other photographers' photos and treat them like a puzzle," says *Traveler* photographer Will van Overbeek. "I ask myself, 'How was that done?' Then I figure it out."

These days, photographic inspiration is as close as the Web. For starters, look at Masters of Photography *(www.masters-of-photography.com),* hosting images by a solid sample of photographic greats, such as Ansel Adams and Margaret Bourke-White. Another treasure of classic photos comes from the collections of New York's International Center of Photography and the George Eastman House *(www.photomuse.org).* The National Geographic Society's own website has a rich photography section *(photography.nationalgeographic.com)* featuring photo galleries, shooting tips, and profiles of Geographic photographers.

Photo books, often of the coffee-table variety, have long been a source of inspiration to photographers and are easier to shop for than ever. "When a photographic project gets to the stage of being published in a book, typically that means the body of work is really solid," says *Traveler* photographer Justin Guariglia. Photo-Eye *(www.photoeye.com)* is a specialized online bookstore that offers more than 30,000 photography books.

Other easy sources of inspiration and ideas are photographers' own websites. These days, most professionals market themselves and even their stock images online. "If you run across an interesting photographer, say, in a magazine article," says van Overbeek, "look for the photo credit, then Google the name and check out the photographer's website."

TIP

A photo-viewing plug-in called Cooliris *(www.cooliris.com)* makes browsing large collections of photographs on photo-sharing websites like Flickr a breeze.

GET READY

Know before you go. We're all used to reading guidebooks and browsing destination websites—maintained by countries, regions, and cities—before traveling. But with a little

extra research, you can better prepare yourself for photographing a location on your travel itinerary. "Being a Boy Scout was the best background for becoming a photojournalist," says *Traveler* photographer Justin Guariglia, an Eagle Scout. "Our motto is 'Be Prepared.'"

Check currency exchange rates at *www.oanda.com*. Get solid background information on a given country in the CIA World Factbook, now published only online *(www.cia.gov)*. Broader in scope are Wikipedia's entries on cities and towns as well as entire nations *(www.wikipedia.org)*. The U.S. Department of State has a travel page *(www.state.gov/travel)* with basic information on countries of the world as well as travel warnings about unstable locales. These warnings may read as overly cautious, but check here for up-to-date bulletins if your destination has a reputation for trouble.

Before leaving home, photographer Macduff Everton makes a point of finding out the current time for sunrise and sunset at his destinations in order to help plan his shooting schedule. "You used to have to find out by reading the local newspaper," he says, but "now it's on weather websites." For 15-day forecasts, check

Read histories or stories set in your destination. "That helps you understand what influences shaped the place," says Kris LeBoutillier.

AccuWeather *(www.accuweather.com)*. Another site, The Weather Channel *(www.weather.com)*, also offers long-term climate information.

Another important step is to learn something about the local culture. Check the Travel and Cultures section of the National Geographic website *(travel.national geographic.com/places)*. Read books set in the destination country or written by a local author. A good source of relevant titles, with short reviews, is *Traveler's* Ultimate Travel Library *(traveler.nationalgeographic.com)*.

Also check out books by cultural etiquette expert Dean Foster, former director of Berlitz International, who has written on many cultures for *Traveler* magazine. His books discuss cultural dos and don'ts of various countries *(www.deanfosterassociates.com)*.

Make shooting lists. Traveler's photographers almost invariably draw up a shooting list before departing on an assignment. At its simplest, a shooting list is merely a checklist of subjects to photograph. In some cases, the photographer will have a list of attractions and sites

Before going to Vietnam, where he got this shot, Kris LeBoutillier read The Cat from Hué *by John Laurence and* Dispatches *by Michael Herr.*

SHOP FOR A CAMERA OVER THE INTERNET

When selecting a camera, try out the model you have in mind, but first narrow your choices online. Read reviews of DSLRs as well as compact cameras on CNET *(www.cnet.com)*. "Its equipment reviews often appear just days after the product is released," says photographer Kris LeBoutillier. "This gives me points to discuss with the salesperson when I go to the camera store. I looked up the Canon G10 [above] before buying it."

Other photographers interviewed for this book recommended Digital Photography Review *(www.dpreview.com)*, founded in 1998. Two related sites that also get the nod are Imaging Resource *(www.imaging-resource.com)* for cameras and SLR Gear *(www.slrgear.com)* for accessories, particularly lenses. "Both sites have no problem pointing out flaws and drawbacks in equipment," says photographer Raymond Gehman. Another good site, Rob Galbraith Digital Photography Insights *(www.robgalbraith.com)*, is run by photojournalists.

Three online camera retailers that *Traveler* photographers have mentioned as favorites are BuyDig *(www.buydig.com)*, B&H Foto and Electronics *(www.bhphoto video.com)*, and Amazon *(www.amazon.com)*. All post customer reviews of products, and the B&H site also indicates whether a reviewer is a verified buyer of the product being reviewed. Check prices at dozens of other online stores at *www.price spider.com*. But beware of stores that lure you in with low prices and then try to gouge you with shipping fees or costly extras. Some sellers will call you after you've placed a camera order and claim to be out of stock—unless you buy accessories.

Shady retailers may send you a gray market product, intended for sale in another country. "Major camera manufacturers usually don't warranty gray market cameras sold in the U.S.," says *Traveler* Senior Photo Editor Dan Westergren. These cameras may use languages other than English in their LCD menus and may have incompatible ports. "They're not a good buy," Westergren says.

provided by a writer assigned to the project. Oftentimes, however, the photographer and writer will be on location at the same time, conferring once or twice, but mostly working independently. In those cases especially, the photographer will create his or her own list, drawing on numerous additional sources.

Some professionals browse photos taken of their upcoming destination. The idea is not to ape others' work but to learn more about what's there—a sort of lazy man's way to scout a location. A resource that many amateur photographers overlook is photo agencies, or stock houses, which sell images by the thousands from contemporary professional photographers and historic archives. You can search their collections on the Web, free of charge. "Before going on a trip, I go to Corbis [www.corbis.com] to see what a place looks like," says *Traveler* photographer Catherine Karnow. Also browse shots of your destination using photo search engines and photo-sharing sites, particularly Flickr *(www.flickr.com)*, which hosts billions of images.

TIP

When requesting permission by letter, "always write to a specific person by name," says Catherine Karnow. "Express honest enthusiasm for their establishment."

Your own personal network of friends, whose knowledge may be more current than a guidebook, can be a resource. If you know someone who lives in or near your destination, pump him for suggestions. "I was heading to Nashville for a *Traveler* assignment," recalls Will van Overbeek. "A friend told me about 'Don for a Dollar' night at the Bluebird Café, where you could hear Don Schlitz, writer of Kenny Rogers's hit 'The Gambler,' perform for a dollar cover charge. So we went, and Don's guest that night was superstar Vince Gill."

Get permission. Increasingly, photographers are adding another chore to their preparation routine: getting permissions. This can mean drafting letters to managers or directors of hotels, restaurants, shopping areas, churches, museums, and historic places on the shooting list. Or it can involve obtaining official permits beforehand from government agencies.

"Tourists can still click away," says Australian photographer Ken Duncan. "But as soon as you pull out a tripod, say, outside the Sydney Opera House or on Bondi Beach, you'll look like a professional and will be interrogated. The worst place of all for this is Uluru [Ayers Rock], where professionals have to pay for permits."

Though amateurs can often shoot freely in public places, getting official permission still has advantages. "It can get you into places that the general public doesn't normally go," says Catherine Karnow, "such as on the roof of a building or inside the kitchen of a famous restaurant, where you can photograph a celebrity chef."

TRAVEL LIGHT, BUT NOT TOO LIGHT

Photography involves both skill and equipment, but as *Traveler* photographer Bob Krist puts it: "Good camera gear doesn't make a good photographer." He eschews the top-of-the-line cameras, because they're too heavy. Like other professional travel shooters, he has learned how to take along only what's essential.

Cameras. Point-and-shoot cameras are lightweight and conveniently compact. They have fixed (built-in) lenses and often extreme zooms, video capability, and easy-to-use programmable scene modes. What's more, underwater housings for point-and-shoot cameras are cheap. These cameras make traveling with a camera extremely easy. In fact, with a point-and-shoot, you needn't carry any other camera gear at all. That's convenient!

Yet none of the professionals interviewed for this book rely exclusively on compact cameras for assignment work. Pictures taken with a compact camera simply aren't as good as those taken with a digital single-lens reflex (DSLR) camera—the type that has interchangeable lenses and that allows you to compose your shot while viewing the actual image captured by the lens.

The megapixel count of the light-gathering sensor on a compact camera may be as high as that on a DSLR, but the compact's sensor is physically smaller. A small sensor crammed with megapixels adds bothersome noise, or grain, to the image. Likewise, the lens on a compact camera is relatively slow—inadequate for low

BEWARE OF DUPLICATE FILE NAMES

When shooting with two camera bodies, set them to sequential numbering to avoid having pictures with duplicate file names. Duplications occur when cameras are set to number files from zero each time you insert a fresh media card. Then, when you transfer the files to your computer, "if you put two files with the same name into the same folder," says *Traveler* Senior Photo Editor Dan Westergren, "one will get deleted."

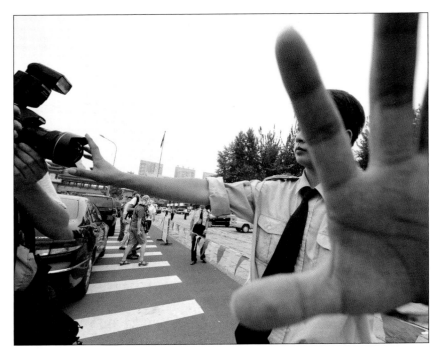

light—and has a long depth of field, meaning it's difficult, if not impossible, to get that blurry background effect from using a shallow depth of field. There are two more strikes against compact cameras: Very few have wide-angle lenses, and many suffer from shutter lag, that painful delay between when the shutter button is pushed and the picture is taken.

A DSLR, on the other hand, can use faster lenses (capable of shooting in lower light) than a compact, has less noise per megapixel, and can shoot more rapidly in a quickly changing scene. Overall, the pictures from DSLRs just look better.

Most professionals travel with at least two DSLR camera bodies, usually identical models that take the same lenses. This gives them a backup in case one camera conks out, but it also allows for greater shooting flexibility. With a lens of a different focal length on each body, the photographer can switch between them without having to remove lenses.

Lenses. Lens selection varies fairly widely among *Traveler* photographers. Some, such as Bob Krist, tend to favor carrying a pair of zoom lenses—a wide zoom (say, an 18-50mm in 35mm equivalent) and a telephoto zoom

A Chinese policeman stops photographers from shooting protesters in a park. Getting permission to shoot can be tough in China.

(perhaps a 50-200mm). Krist might have a prime (fixed focal length) lens or two in his bag as well. Aaron Huey goes longer: On hiking assignments, he'll carry a wide zoom and a 100-400mm, though he prefers to shoot with prime lenses when weight isn't such a factor. (His 85mm is a favorite for portraits.) Photographer Richard Nowitz can sometimes get by with a single zoom. "My favorite walking-around lens is a 28-200," he says. Will van Overbeek swears by his fast 28mm (f/1.8) and 50mm (f/1.4) primes, which work in "really low light."

Whether you use a prime or zoom lens, you'll want a range of focal lengths extending from at least 24mm or 28mm at the wide end to 200mm at the long end. If you shoot wildlife extensively, go longer, say 300mm or 400mm.

Photographers will mix and match lenses, depending on the needs of a particular assignment. Huey says when he's shooting a festival, he'll take two camera bodies, putting a wide-angle prime lens on one and a zoom lens on the other. Some photographers will carry specialty lenses or accessories, such as a fish-eye lens or macro lens (for close-ups) as well as teleconverters, an inexpensive way of extending the focal length of a lens.

The good news, according to Krist, is that zoom lenses are improving in quality, making them suitable for a wider range of applications. That means carrying two or three overlapping zoom lenses is becoming a practical solution

Jim Richardson's camera bag holds an assortment of flash units, lenses, filters, memory cards, cables, and controllers.

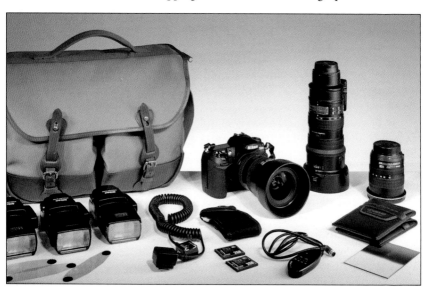

for many travel photographers who don't want to haul around a bagful of prime lenses.

Filters. Filters may have been more useful in the days of film, before colors and saturation could easily be adjusted on the computer. But filters also have a place in digital photography. You still need to protect your lenses from scratches and dust with UV filters. Two other filters still commonly used are the polarizing filter and the graduated neutral-density filter. (Note: Filters are normally used one at a time, not stacked atop each other.)

TIP

For Justin Guariglia, shooting lists are dynamic. He's always adding to them, if not for a current assignment, then for a future one. "Always carry a notebook," he says.

The polarizing filter reduces the effects of scattered light, effectively cutting through haze, darkening the blue sky, reducing glare and reflections, and adding saturation and contrast. The graduated neutral-density filter reduces the dynamic range of a scene so that your camera can capture it all. The filter "graduates" from clear to gray; the gray area darkens blown-out parts of the composition. Use this filter to darken a bright sky, for example, while still capturing detail in the foreground. Or use it to do just the opposite: Huey needed to tone down the brightness of whitewashed logs in the foreground of a beach scene while still capturing detail in the dark, brooding clouds overhead. So he oriented the filter with the darker side at the bottom of the lens. Graduated neutral-density filters come in varying strengths (achieving one, two, or three stops of darkening) and with either a hard or a soft gradation line.

A regular (nongraduated) neutral-density filter is also useful. It reduces all light penetrating the lens, letting you, for example, use a slower shutter speed in a brightly lit scene, when you might want to capture motion effects (say, of a waterfall).

Other filters can add special effects. By combining a diffusion filter and warming filter and using high-speed film, Krist gave a hazy, pointillist look to his pictures of Italy for a *Traveler* feature titled "With Frances Mayes in Tuscany." That was before Krist made the transition to digital photography. If doing the same treatment today, he says, he'd probably still use the filter pack instead of relying on digital post-processing to achieve this special effect. Why? "Because I don't like to spend hours in front of the computer screen," he says.

Chapter 2
Master the
Core Concepts

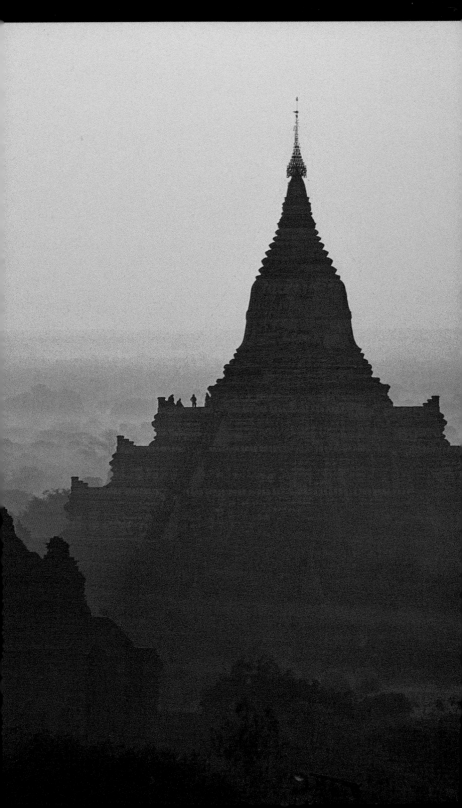

2 *Master the Core Concepts*

Previous pages:
Glowing at sunrise,
the temples of Bagan,
Myanmar, are seen
with atmospheric
perspective heightened
by a telephoto lens.

To shoot like the pros, you need a grounding in the core principles of photography, particularly composition, lighting, and exposure.

COMPOSITION

Start simple. A central concept of photography is the arrangement of elements in the picture, called composition. And like good writing, good composition has clarity and strength—qualities often lacking in pictures taken by amateurs. "The biggest mistakes I see in pictures at photography workshops are a distracting, busy background, a lack of a central point of interest, and a general flabbiness to the composition," says *Traveler* photographer Bob Krist, who has written books and magazine columns on photographic technique.

Fill the frame. "Find what's interesting in a picture and fill the frame with it," Krist continues. That often means stepping in close, so that your subject is not surrounded by empty space or clutter. As you look at a scene, your brain tends to edit out extraneous details—but the camera records them, often ruining a picture. Train yourself to see a scene as the camera does and compose accordingly, a challenge even for professionals.

"The first pictures I take on an assignment are cluttered," says *Traveler* photographer Justin Guariglia. "You have to get into a mind-set of cropping, editing down, trying to find that iconic image." Studio and advertising photographers have complete control over their subjects, Guariglia points out, and can move them to suit the composition. But travel photographers have to achieve the same strength of composition in the real world, without such control. "The challenge is, how do I move an inch this way or that, or step back or forward by one foot, to get that image?" Guariglia says. "By the end of the first day, as I find the groove again, the shots get cleaner."

Add layers. Only after you can shoot clean, simple images should you start to add layers—that is, multiple elements beyond the main subject, such as foreground and background elements. "After you know the rules,

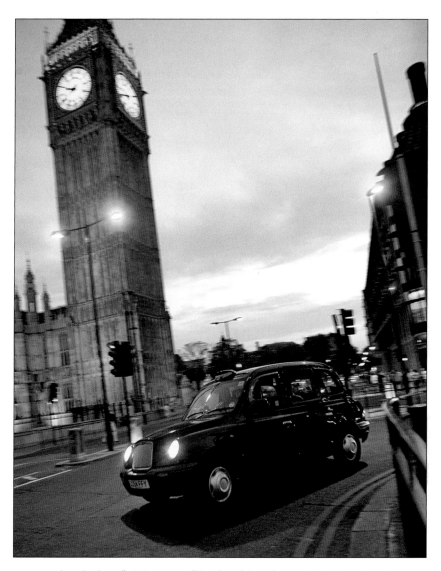

you can break them," Krist says. "But breaking them first is not mastery of photography. It's mush."

Know the rule of thirds. A basic rule of composition is to keep your subject off center. A centered subject tends to be lifeless. In your mind's eye, divide the picture frame into thirds horizontally and vertically, overlaying it with a grid of straight lines. The four points where the horizontal and vertical lines intersect will surround the center. Position your subject on any of these four points.

Will van Overbeek got a novel shot of London's Big Ben by "Dutching the angle" and including an iconic foreground element, the taxi.

Mentally divide your frame into thirds— down and across. Avoid positioning your subject dead center.

Find leading lines. Landscapes are full of linear elements—roadways, train tracks, fencerows, ridgelines, tree branches. Use these lines to lead the eye into your picture. Leading lines are most effective as diagonals.

Frame it. Paintings look better when framed, and picture compositions often do, too. A frame is an element in the foreground that lends depth to your picture. It might be a doorway, a window, a person, one or more trees or branches. The framing element can go along one, two, or three sides of a picture, or all the way around.

Lend scale. When your subject is of indeterminate size—a mountain, a body of water, a snowscape—add a sense of scale by including something of known size, such as a person, a car, a tree, or an animal. This helps viewers understand what they're looking at. A common criticism I hear in *Traveler* staff picture reviews is, "It doesn't read." That means, simply, that the photo is unintelligible, often for lack of scale.

Change angles. Professional photographers move their bodies to get the picture. They bend their knees, stretch their arms, lie on their backs or stomachs, and climb up on chairs, ladders, cars, or buildings. It's the amateur who shoots everything at eye level. Move to the side instead of shooting something straight on. Get

down low to photograph children or to add pleasing distortion. Get up high, but not too high, to add context or to find juxtaposition. In short, move! The result is fresh perspective.

When shooting a *Traveler* feature called "London Calling," Will van Overbeek got a fresh view of the Big Ben tower by "Dutching the angle," that is, tilting the camera so that the oft-shot tower was slanting to the left. "I simply twisted the camera in relation to the horizon," van Overbeek says. When shooting "Best Little City in America," an article about Austin, Texas, van Overbeek got down low to shoot a portrait of 93-year-old musician Pinetop Perkins. "I held the camera at about the height of the middle button of his shirt," van Overbeek says. The composition emphasized Perkins's left hand, which held a cigarette up to his mouth.

Change the focal length. Switching from a standard lens to a wide-angle or telephoto can have dramatic effects on composition, and the more extreme the lens, the more dramatic the effect. A wide-angle lens can create a sense of place, showing a subject in context. The wider view can capture an entire scene, telling a story. In his coverage of "The High Road to Machu Picchu," Aaron Huey shot wide to show the trekkers hugging each other at the pinnacle of their journey, atop Salcantay Pass.

The advantage of a telephoto lens is just the opposite. It effectively cuts out excess elements, allowing you to focus on a central subject. For this reason, telephotos can be good for portraits. For the *Traveler* article "The Last Real America," about life in rural eastern Montana, Huey got a dramatic portrait of a cowboy by using an 85mm lens, his favorite focal length for portraits. Telephotos also compress space, making distant objects appear closer to you or closer to each other. Finally, telephotos have a shallow depth of field (see below), making them useful for blurring the background.

Control the depth of field. Depth of field (DOF) is the depth to which a scene stays in focus. With shallow DOF, little more than the focal point, or subject, of the composition remains sharp. With long or deep

TIP

When attempting to shoot a multilayered composition, think in terms of foreground, mid-ground, and background elements. One of the elements, often the foreground, should be dominant, to avoid a cluttered look. Use techniques of graphical perspective, such as overlapping, foreshortening, and atmosphere, to add depth to the composition.

DOF, elements in front of and behind your subject stay in focus, too. Controlling DOF to maximum advantage is one hallmark of a professional shooter. This is done in part through lens selection: wide-angle lenses have deep DOF and telephotos have shallow ones.

DOF is also controlled through adjustment of the aperture, the hole in the lens through which light passes. Opening an aperture wide—that is, adjusting the lens to a low f-stop—results in a shallow depth of field. Photographers use this setting to dramatically blur the background, helping their subject to pop out. Stopping down the lens to a high f-stop (small hole), results in a long depth of field. This is useful for many landscape compositions, in which you want every part of a scene to be in focus.

TIP
Rarely do you want the horizon line running across the middle of the frame. Tilt the camera up or down to move the horizon line for a more pleasing composition.

LIGHTING

Just as important as mastering good composition is understanding how to use light. Think of a camera as a light-gathering implement.

How is the scene lit? Train yourself to notice where the light is coming from. Is it direct sunlight? Light from a window? Light from above? From the side? Is it forming shadows? Is it natural light? Artificial?

Front light and top light. When you shoot a scene with the light coming in over your shoulder, that's front light. Front light is serviceable but can be dull for lack of depth. Top light, the kind that comes at midday, is even worse, casting unflattering shadows. "Front light obliterates the shadows," says Krist, "and top light casts the wrong kind of shadows. Midday is the worst time for photographs, but it's when most travel photos are taken."

Side light. This is "magic hour" light, coming in early morning and late afternoon. Professional photographers are busiest at these times because the light is rich in tone, and its low angle casts pleasing shadows that give definition and depth to subjects. "Side light is great for landscapes but can be too harsh for people shots," Krist adds.

Backlight. Backlight can make for dramatic images as well. Place your subject in the foreground against a sunrise or sunset to achieve a dramatic silhouette. Or use backlight to get a halo effect in a portrait, while you light

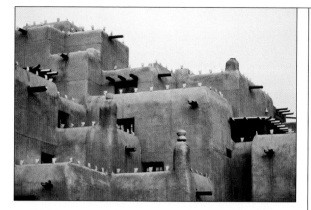

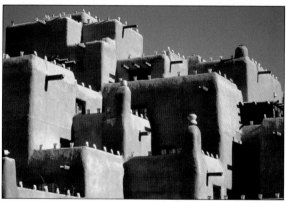

These two shots of the same hotel in Santa Fe, one with "magic hour" light, demonstrate how crucial lighting is to the success of your photo.

the face with fill flash. "Avoid having the backlight shine directly into your lens," Krist says. You might accomplish this by blocking the light with your subject or with another element, such as a tree trunk.

Overcast light. A gray day can be depressing, but professional photographers are out shooting anyway. Light coming through cloud cover is diffuse and useful for shooting portraits. So is the light in open shadows. Huey's cowboy portrait, referred to above, was shot in the shadow of a barn, where the light was even and soft. An overcast day can also be good for shooting street scenes, because it is free of harsh reflections. "On overcast days, the only thing I do differently is to crop out the sky, which would be a big, white negative space in the picture," says Guariglia. "On sunny days, I keep the sky in."

When you're on location, plan your shooting schedule with a map in hand. Light has different qualities

depending on the time of day, not the least of which is direction, with the sun rising in the east and setting in the west. Do you want to shoot that pyramid with backlight or frontlight? On which side of the Grand Canyon do you want to be at sunset? These are questions the purposeful travel photographer answers ahead of time.

EXPOSURE

Exposure simply refers to how much light you let into your camera and for how long. An image is said to be underexposed if not enough light has come in, creating dark shadows. An overexposed image, on the other hand, suffers from too much light. It's said to be "blown out."

The photographer controls exposure by adjusting the aperture (size of lens opening) and shutter speed. A third variable that affects exposure is light sensitivity, once known as film speed, measured by the ISO number. The ISO range varies with cameras but may extend from 50 to 3200 or higher. Light sensitivity increases as the number increases. Shooting in a low-light situation without flash? A high ISO may be called for. Just remember that noise, or grain, increases with the ISO number as well. Generally, you want to use the lowest ISO setting the conditions allow in order to minimize noise. When choosing an ISO, consider ambient light level, whether your subject is in motion, and whether you want to use a tripod.

Manual versus automatic. With today's high-tech cameras, it's tempting to let the camera do your thinking for you. Just set it on automatic (or "program" mode), point, and shoot. What's wrong with that? In some situations, nothing. Program mode may be particularly useful in a fast-changing situation, such as white-water rafting, in which you don't have time to adjust the camera between shots. You can still tweak the camera to current conditions by adjusting the ISO setting or by using exposure compensation, where the camera automatically lightens or darkens the picture by a set exposure value (EV). This setting stays in effect until you change it.

However, most pros usually use some degree of manual control rather than the full automatic setting. As stated above, you can manually adjust the aperture to blur the background in order to emphasize your subject or, conversely, to keep the entire composition in focus.

TAKE YOUR CAMERA TO BOOT CAMP

The worst time to learn how to use your new camera is during an expensive, once-in-a-lifetime trip to an exotic destination. Master the core concepts discussed in this section closer to home, before you get to the Egyptian pyramids. "Practice until everything about your camera gear is second nature," says photographer Jim Richardson. "You don't want to be standing in front of someone you're trying to photograph, broadcasting your self-doubt about using your equipment."

But you don't need to commit your camera's entire owner's manual to memory, Richardson says. "Your camera has loads of features, but you only need to know a few things well—techniques that you will use repeatedly and that you can pull off in fresh situations. That's better than knowing a lot of things poorly."

Try out some of the many shooting strategies outlined in this book before leaving on your trip. "You don't even have to leave home to do it," says photographer Will van Overbeek. "Stand outside your house and shoot cars going by to learn motion techniques," he says. "Throw your owner's manual in your carry-on bag," he adds, "and review it on the airplane."

Richardson certainly takes the learn-it-close-to-home approach. Not long ago he bought some little strobe lights that he planned to use while photographing pubs in Lorient, Brittany (above). To get ready, he took the strobes to a tavern in his own hometown of Lindsborg, Kansas. "I wanted to learn how to position the strobes in a way that would light the pub up naturally," he says. "That took some practice."

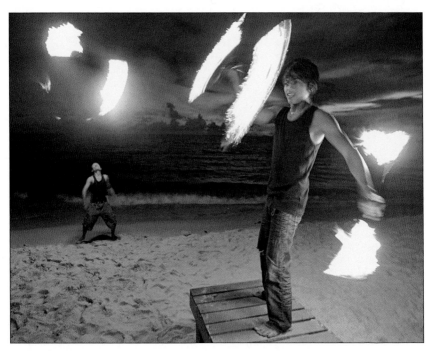

Kris LeBoutil-
lier exposed for the
"brights" (sky and
torches), then bracketed
the exposure to make
sure one of his frames
would correctly balance
the light.

You can adjust the shutter speed to freeze action or to achieve blurry motion effects. So in addition to opting for the full manual option—in which you set aperture and shutter speed yourself—you can choose to control one of those two variables and let the camera control the other.

Aperture priority auto. Krist estimates that 90 percent of the time, he shoots in aperture priority automatic mode, setting the aperture by hand and letting the camera select the shutter speed. "That leaves me in the driver's seat," he says. For a blurry background due to shallow depth of field, he'll open up the aperture and let the camera set a fast shutter speed. For motion effects, he'll close down the aperture, forcing the camera to set a slow shutter speed.

Shutter priority auto. Shutter priority automatic mode works just the opposite: You control the shutter speed and let the camera adjust the aperture. This is the setting of choice for those wanting absolute control over motion effects.

The histogram. A helpful tool on most digital cameras is the histogram. This graph, which appears on your camera's LCD monitor, shows the distribution of tones in an image. The dark tones, or shadows, appear

to the left on the graph, mid-tones appear in the middle, and highlights appear to the right. Check the histogram when lighting conditions are contrasty or otherwise tricky, advises Krist. "The image could look good in the LCD and still not be a good exposure," he warns.

The histogram typically looks like a side view of mountains and valleys. If high peaks slam up against the left or right sides of the histogram, your image is likely "clipped"—that is, it may contain areas of pure black or pure white, respectively, meaning no detail has been recorded by the camera sensor. Krist says the simplest rule of thumb is that you want the histogram line to hit the floor of the graph before hitting either side. Clipped highlights can be particularly ruinous to an image, so some camera makers have built in a warning function in which clipped areas blink. "When you get the blink-ies," Krist says, "stop down the aperture until they go away."

White balance. A big advantage of digital cameras is their ability to automatically adjust to lighting conditions of varying colors, referred to as temperature. When the camera is set to "automatic white balance" (AWB), it renders colors accurately no matter if you're shooting indoors, in bright sunlight, or on a cloudy day. AWB is a good setting most of the time. Sometimes, however, you want the color of the light to be apparent, such as during sunrise and sunset. For that reason, experiment with the other white balance settings on your camera, like "daylight" or "cloudy," to capture the color of light most true to the scene.

TIP

Bracketing—shooting the metered exposure and one or two stops above and below it—isn't as necessary when you're shooting raw files. It can be needed more when shooting JPEGs.

USING A FLASH

Some travel photographers, including a few interviewed for this book, disdain flash photography. It produces harsh, "deer in the headlights" effects, they say, with blown-out subjects against inky black backgrounds. And with the high-sensitivity light sensors in today's digital SLRs, a photographer can use a high-ISO setting in low-light situations without needing flash at all. It may come as some comfort to readers, then, that many *Traveler* story assignments have been shot without flash. But it doesn't follow that flash has no place in travel photography.

"Some of my colleagues may be making an ethical stand out of a lack of knowledge," warns Krist. The latest smart flashes—the "evaluative TTL" (through the lens) flash systems connected to digital cameras—can be extremely effective, he says, and have a place in every travel photographer's kit.

Use it as a last resort. Krist agrees that flash should be used sparingly. "My first option is always available light," he says. "If I need to shoot a restaurant, I'll choose one with good light from windows. But saying I won't use flash at all is like a prizefighter tying one hand behind his back."

Even out a contrasty scene. Use flash to reduce contrast in a scene that has both bright and dark areas, Krist says. When shooting a cover story on Rome for *Traveler,*

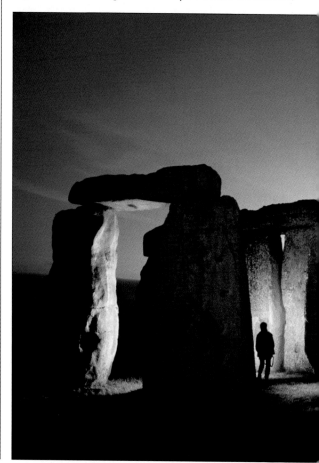

While the standing figure held still, Richard Nowitz "painted" the monoliths of Stonehenge one by one with his flash during a long exposure.

Krist recalls photographing a café in which some parts of the interior were five stops darker than others. He used a flash to even out the exposure. Likewise, use the fill flash setting at midday under bright sun to fill in shadows under noses. "You have to be close to the subject," says van Overbeek, "what I call 'knife-fighting' distance, certainly within ten feet." Try fill flash in any close-up scene where the foreground is considerably darker than the background, such as when shooting a table of food set under a canopy on a sunny day. Today's flash units have adjustable fill flash settings. Check results as you go, and if the flashed area is too hot, dial the unit down a stop or two.

Blend flash with ambient light. Flash units have a maximum "sync" speed at which they can synchronize with

the camera shutter. Set your shutter speed any faster than that maximum, and you'll get incomplete lighting, because the camera shutter closes before the flash unit has completed its work. Krist adds that photographers shouldn't necessarily shoot as fast as the maximum sync speed, anyway. By shooting at a much slower speed—say, at what the camera's light meter suggests for ambient light alone—you achieve much more natural results, a blending of flash light with ambient light. This way the camera will capture the background, lit with ambient light, as well as the foreground, lit with the flash. This technique, called "slow sync," is available as a setting on most digital cameras. On some cameras, it might be labeled as "night mode."

Drag the shutter. When employing flash with slow sync, use a tripod, or at least steady the camera against a solid object, to get everything in focus. If the subject is moving, hold the camera and pan with the subject, letting the background go blurry. This latter technique is called "dragging the shutter." The results are dramatic, giving the look of motion to dancers in a nightclub or to cars moving by on a busy street. For best results, use this slow-shutter-with-flash technique with your camera set on "rear curtain sync." In this setting, the flash fires at the end of the exposure time, causing blur lines to appear behind the moving subject—the way we expect motion to be represented. If you use the camera's normal setting, or front-curtain sync, the blur lines go out in front of the moving subject, which looks unnatural.

Bounce the flash. Another useful flash technique is to bounce the light off a wall or ceiling instead of pointing the flash directly at the subject. This diffuses the light, making it less harsh. It works best with white or light-colored walls.

Use an off-camera flash. The latest flash units can be removed from the camera and fired wirelessly. Remote flash, which sometimes involves multiple flash units firing at once, gives the photographer a great many more options in lighting a scene. In particular, it allows you to achieve side-light effects. For his *Traveler* article on the

TIP

Sharpen your skills by giving yourself an assignment close to home. Bob Krist repeatedly shoots his home environs of Bucks County, Pennsylvania—old stone barns, craftsmen, a tilemaking factory, horse farms with beautiful fences, a historic steam railroad. Part of a recent self-assignment was recording sounds to use with slide shows. "This kind of assignment helps me grow," Krist says.

Polynesian island of Bora-Bora, Krist got a memorable shot with side light of master tattooer Roonui, his body covered in tattoos. Krist perfectly blended the ambient light of the horizon with an off-camera flash held by his wife. The flash, coming from the side and diffused through a 20-inch umbrella, created pleasing shadows on the man's body, giving him a three-dimensional look. The picture filled a page in *Traveler*.

Painting with flash. An advanced flash technique that some *Traveler* photographers use is referred to as "painting" with the flash. It's useful when shooting a dramatic subject at twilight or after dark. You put the camera on a tripod, set the shutter to "bulb"—which allows for prolonged, multiminute exposures—and then walk around firing a portable flash (or even a flashlight) at whatever you want to illuminate, using multiple bursts of light as needed. Photographer Richard Nowitz used this technique to photograph scenes at Stonehenge and Easter Island for *National Geographic World* magazine. After setting up his composition, he walked up to the stone monuments and painted them one by one with light. "It's best to wear black clothing," he says, "so if you hit yourself with the flash, you won't show up in the picture." The technique is also used for photographing scenes in caves, which are, of course, pitch black.

Bob Krist used an off-camera flash to light this master tattooer on Bora-Bora. A "slow synch" setting let him fill out the scene with ambient light.

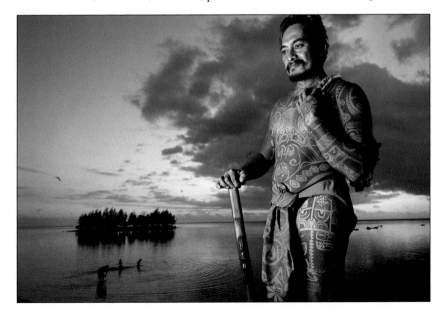

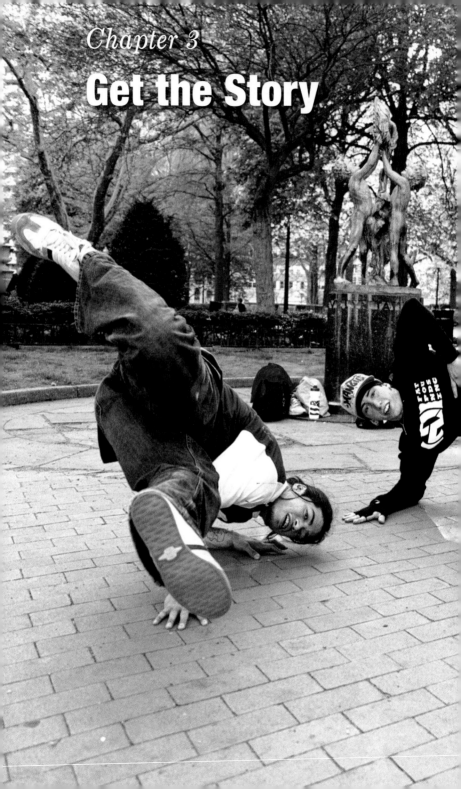

Get the Story

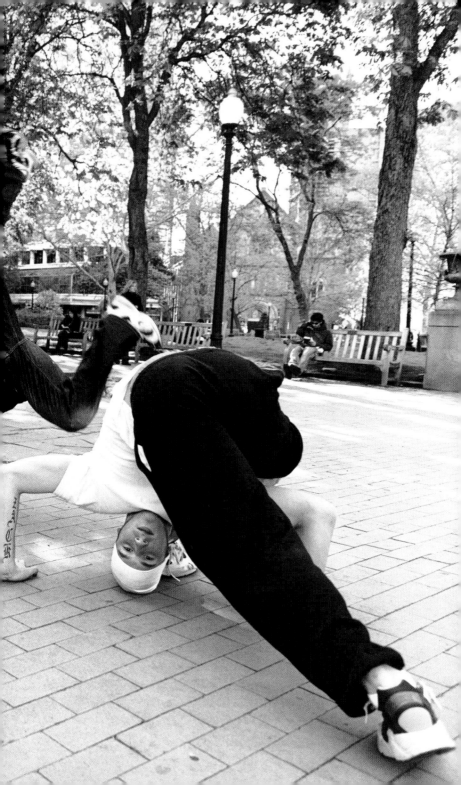

3 | *Get the Story*

Previous pages:
For the Traveler *story*
"Philly, Really,"
Raymond Patrick shot
teens break-dancing on
Rittenhouse Square.

Many photographers dream of getting published in one of the National Geographic Society's magazines. A surprising number of photographers do get their foot in the door—the magazines are always looking for fresh talent—by showing their portfolios to a Geographic picture editor. They hope that their superb images will win them an assignment. But the ability to take great photographs, though necessary, is not sufficient. That's because our magazines, strictly speaking, aren't photography publications. They're journalistic endeavors. That means our pictures must go beyond being stunning. They must also tell a story.

At *Traveler*, we are showered with story proposals that offer no story at all. Most merely tout the virtues of a particular destination. But, as Editor in Chief Keith Bellows likes to tell freelancers, "We don't need help finding places. We look for a strong story line that makes readers wonder what will happen next or that offers some drama, surprise, or revelation." In our printed guidelines for photographers, you'll read this: "A carefully considered proposal combines support for doing a particular destination with some premise or hook." Paul Martin, *Traveler*'s former executive editor, adds, "Paris is not a story. Paris is a place."

WHAT MAKES A TRAVEL STORY?

Every journey is, or should be, a story with a beginning, middle, and end. Furthermore, every journey is unique. Your itinerary may have been followed a hundred times before, but your experiences of the route will be fresh, and your pictures should be, too.

Your photos should evoke your particular trip, capturing your travel companions, the local people you interacted with, and the events and activities you engaged in while you were there. "The fundamental premise is that your pictures need to reflect something that you really experienced," says *Traveler* photographer Jim Richardson.

Richardson compares the task of shooting a travel story to producing a play. "You have to build the scenery

for your sets," he says, "but also populate the production with characters and have a plot. Many people stop at shooting the scenery. But you need to have people on the stage, acting."

The simplest kind of travel story is the travelogue, a straightforward recounting of the events of the trip. Even this rudimentary kind of story takes some thought. When shooting a family trip, for example, it means doing more than photographing loved ones posed in front of the Eiffel Tower. Travel is movement, not a

Jim Richardson climbed a ladder to get this shot of a printer's devil for a story on haunted York, England.

sequence of still lifes. Get shots of the family packing, hailing a cab on a busy boulevard, planning the day's outing with maps spread across the hotel bed, interacting with a waiter, bargaining in a market.

"You want to shoot your family member at the moment when they're involved, when they're fascinated by something," says photographer Kris LeBoutillier.

Travel stories get better when they go beyond the mere travelogue, offering a theme, conceit, or concept. "Born to Be Wild" was writer Pat Kelly's tour of Mexico's colonial cities, photographed by Justin Guariglia. The idea of the tour became far more interesting when we learned that the trip brought together three old college chums determined to relive their rowdy, motorcycling youth—30 years after graduation.

One shot showed the three stopped by the side of the road, smoking cigars to celebrate a rider's 50th birthday. Likewise, Joyce Maynard's bicycle trip through Tuscany and Umbria, titled "Shifting Gears" and shot by photographer Aaron Huey, went beyond travelogue with the theme of a mother and (grown) son reunion, happening after years of separation. Pictures of the two of them together—pedaling down a winding rural road; resting, sweaty and spent, on a sidewalk in the hill town of Castel Rigone—added poignancy to their tale.

TIP

Travel photography should go beyond monuments and scenery. A story line gives your photography work to do and a method of evaluating your own success.

Other *Traveler* features were also based on clever conceits. Tim Cahill's "Dublin Without a Pint," shot by Pete McBride, illustrated a novel way to explore an unfamiliar city—via a marathon race. In "Chasing Matisse," shot by Michael Melford, the writer set out to visit all the places where the famous artist lived and painted in France. An exploration of the City of Brotherly Love, "Philly, Really," shot by Raymond Patrick, made a strong case that Philadelphia was destined to become America's "next great city." This illustrates trend as concept, as did "Trading Places," shot by Peter Bendheim and Amy Toensing, a story in which two travelers swapped houses halfway around the world and walked in each other's shoes.

Beyond travelogues and trends, yet another common angle for a travel story is the *pilgrimage* back to a beloved old haunt or previous home. The idea is to

discover how the place has changed—for better or worse—over time, sometimes suggesting a "then and now" picture treatment. In "Up from the Ruins," we sent writer Priit Vesilind to Estonia, from which he and his family had fled 48 years earlier to escape the Soviet occupation. Photographers Sisse Brimberg and Cotton Coulson brought back pictures of Vesilind's hometown that evoked the past and gave a sense of the present. One photo juxtaposes the author's rebuilt family home next to the ruins of a 500-year-old convent.

Perhaps the most compelling travel story angle of all is the quest. Every journey is a quest, of sorts, even if all you're seeking is rest and relaxation. But focusing on the quest brings a real narrative drive to your travel story. We sent writer P. F. Kluge and photographer John Kernick along the back roads of Idaho, from hot spring to hot spring, for an article titled "In Search of the Perfect Soak." With each discovery, they refined their vision of what soaking perfection would be. For "The Quietest Place on Earth," another quest story, writer Edward Readicker-Henderson and photographer Justin Guariglia sought serenity, which led them to the Canary Islands off the coast of Africa. Seeking the superlative or the perfect example of something—even if it's just

Jim Richardson used multiple strobes to light this cellar, then jiggled the camera for an ethereal effect.

a bowl of wonton soup—is a primal quest that can be applied to almost any trip.

For an October issue, *Traveler* sent Richardson to York, England, to photograph a story titled "The Most Haunted City in the World." That theme, Richardson says, "gave me a very focused way of looking at the place." All of his preparation work—reading guidebooks and history books, browsing images on the Internet—was filtered through that lens. "The story angle let me put on my blinders," he says, "so that I could bypass certain aspects of the city and focus on those things that would reflect the city's spiritual acuity."

The lead shot of the story was of a printer's devil, a nine-inch-high figurine hanging above a printer's shop along a medieval street. When he saw it, Richardson knew immediately that it served his theme. "I borrowed a ladder so I could get up there with him," he recalls. "And suddenly, when I had the right vantage point, he loomed big in the picture. He had this leering look, and sometimes the people walking by down below would look up at me askance, which was perfect. It became a scene with drama."

The text of the article recounted a famous ghost sighting featuring Roman soldiers. Richardson couldn't find

ghosts to shoot, but he did find the Roman Bath Inn, which happened to have a couple of history-loving patrons on site dressed as Roman centurions. Richardson found yet another scene supporting his theme at the York St. Mary's, a deconsecrated church that has been turned into an art space, where votive candles were lit for lost loved ones. "There was such a spiritual quality to it," he says. "I saw that and said, 'Whoa! This fits!' "

Once you have your story angle, Richardson continues, "your pictures have work to do, and you have a way of evaluating how well they do it." Without an angle to shoot to, "you generally go out looking for what you think someone else would regard as a good picture."

And if you don't have a story assignment? "Invent your own," Richardson says. "You need to tell a story, not write an encyclopedia. You have to have a viewpoint."

To find your own quest or conceit, research the destination to uncover its most distinguishing attributes. Examine your own reasons for wanting to go. Talk to your travel companions before the journey to discover their goals for the trip. Is someone hoping to buy a beautiful handmade weaving? To reunite with the family they stayed with during a semester abroad? To learn to cook authentic paella? Any of these could make a story angle with broad reader appeal.

Adding a story element, then, is the best way to make your travels compelling. Contrast the focused ideas presented above with the generic, forgettable angles commonly pitched to travel magazines: "Enchanting Vienna," "Idaho's Bubbling Hot Springs," "Surprising Philadelphia," "Historic York." Should you ever want to pitch a destination idea to a magazine or Sunday newspaper travel section, having a strong story element will make your pitch stand out above 99 percent of all others.

CHALLENGE YOURSELF

Have a friend supply you with the text of a magazine or newspaper article about your hometown or region—or about a destination you're planning to visit—*without* the photographs that appeared with the article. Shoot the story yourself. Afterward, compare your photographs with those that appeared in the published article. This will help you start thinking like a professional assignment photographer.

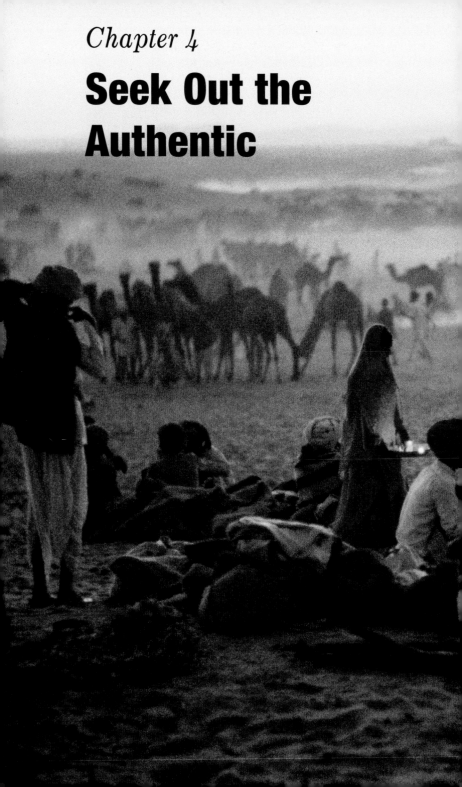

Chapter 4

Seek Out the
Authentic

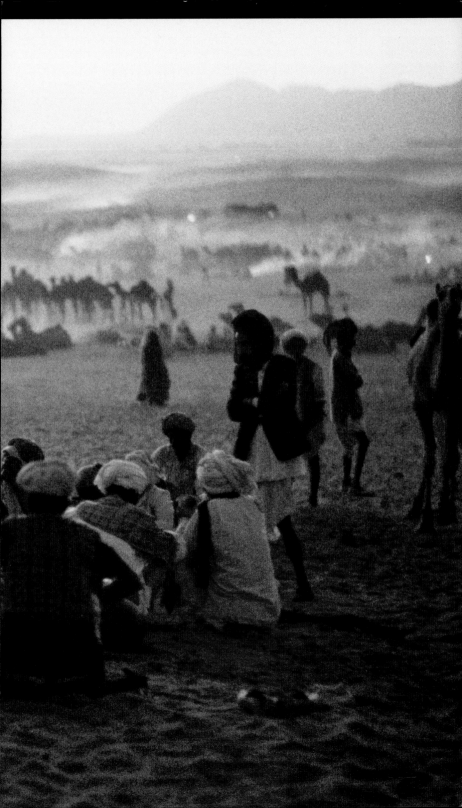

4 | *Seek Out the Authentic*

Previous pages:
The Pushkar
Camel Fair in
Rajasthan, India,
is a well-attended
cultural bonanza
for photographers.

Today's travelers are intrigued by the authentic. We like places that still have their own distinctive identity—culture, heritage, environment—intact. "A driving force in travel photography," says photographer Bob Krist, "is that you want to go someplace where you can see something different from what you have at home."

But while travelers relish authenticity, the destinations may not. The imperative to modernize, the temptation to cash in on high-volume "sun and fun" resorts, the lack of respect for indigenous populations—all of these can lead to a decline in the attributes that attract us to a place to begin with. *Traveler* magazine has been working to arrest this trend toward homogenization. To that end, the magazine keeps an eye on threats and improvements to travel spots in a regular department called "Destination Watch." And each year, we run a feature report in conjunction with a "Places Rated" destination stewardship survey, measuring how well popular destinations around the world are holding up.

Jonathan Tourtellot, an editor at *Traveler* and the director of the National Geographic Center for Sustainable Destinations (CSD), coined the term *geotourism* in 1997 to encapsulate a new ethic. The idea is to harness the power of tourism to help sustain a destination's environment, culture, heritage, arts, local economy, and overall sense of place.

THE PHOTOGRAPHER'S ROLE

Photography, particularly travel photography, has a role to play in geotourism by helping to document what's left of the authentic. *Traveler* contributing editor Chris Rainier travels the world with a team that records and preserves disappearing languages; he photographs the indigenous people who still speak them. In addition to participating in that project, called Enduring Voices, Rainier also directs the All Roads Photography Program, which puts cameras in the hands of indigenous people themselves to document their own cultures.

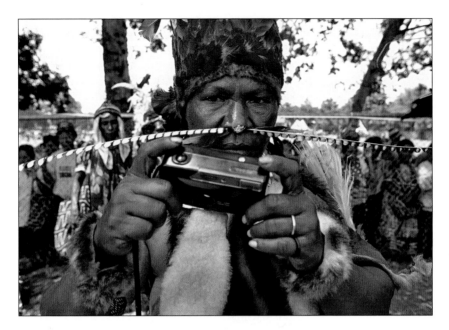

Rainier illustrates the importance of documenting authentic cultures by pointing to the work of Edward Curtis, who photographed Native American cultures in the early 20th century. "In a recent documentary film," Rainier says, "a modern Ute Indian said that it was because of the Curtis photographs that they were doing the Sun Dance again."

Rainier's multiple trips to New Guinea to document the lives and customs of indigenous people there resulted in the picture book *Where Masks Still Dance: New Guinea.* "As I was finishing up the book," he recalls, "the prime minister of New Guinea commented that one day the young boys of New Guinea would look at these pictures and say, 'We can build those masks again.' " Commenting on the power of photography, Rainier explains that "someday it can be used to jumpstart a disappearing culture."

A tribeswoman uses a point-and-shoot camera during the annual tribal sing-sing in Goroka, Papua New Guinea.

DO YOUR RESEARCH

Not every travel photographer is destined to be the next Edward Curtis or Chris Rainier. But all of us can use simple strategies to bring an element of authenticity into our pictures, including photos of indigenous peoples.

Krist and Rainier agree that truly indigenous cultures untainted by the modern world are increasingly

rare. And while it's true that going far off the tourist trail may lead to interesting people who aren't constantly bothered by photographers, tourism's reach is ever broadening. "It's naive to think there are cultures out there—developing or otherwise—who haven't seen their share of photographers," Krist says. The goal, then, becomes not to find people untouched by the modern world but to find those who still embody their traditional culture—and to approach them with tact.

"The local mores about being photographed vary wildly from region to region," Krist advises. "Photographers love Papua New Guinea not only because the people there are probably the most colorfully dressed and made-up people on Earth, but also because they love to be photographed." In other places, he continues, such as parts of the Caribbean, there are "feelings

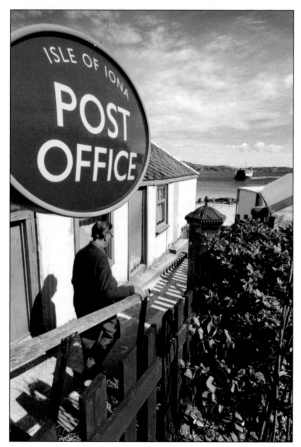

A visitor leaves Scotland's Isle of Iona post office. The island is often busy with tourists all day but then clears out—after the last ferry leaves.

of exploitation and overtones of colonialism involved. They'll throw rotten fruit at you just for having a camera around your neck." Your pretrip research may provide insight into how you will be received.

Still, as Catherine Karnow points out in Chapter 5, "Photograph People in Places," the right approach and demeanor can make it possible to photograph almost any group of people, anywhere. Photographer Michael Melford boils down his advice for shooting in developing countries to this: "Know the customs, and ask permission before shooting."

TIP
All of us should try to be geotourists, fostering the geographical character of a place—its environment, culture, heritage, and aesthetics—and the well-being of its residents. Let's support those destinations whose governments, tourism officials, and private businesses practice good stewardship, enhancing a destination's distinct character rather than destroying it.

ARRIVE EARLY, STAY LATE

Authentic culture is sometimes as close as the nearest market or festival, and these typically are likely to be *on* the tourist trail. Krist cites the Pushkar Camel Fair in Rajasthan, India, and the dance festivals in Bhutan as good, if well-known, shooting opportunities. "In Bhutan, there are authentic dances going on, but half the audience are members of photo tours," he says. "These things aren't any less authentic for being photographed," he continues, but being the only photographer there is exceedingly rare.

"I was recently shooting a festival in Kerala, India," he continues, "with 50 caparisoned elephants and thousands of musicians. That was the first time I've been to a major festival in 15 years that wasn't absolutely overrun with Western photographers."

When that's the case, arrive early, before the crowds. " 'Go early, stay late' is my motto," says photographer Aaron Huey, who photographed "The High Road to Machu Picchu" for *Traveler* magazine. That story covered a "flashpacking" (arduous but high-end) tour that started in Cusco, Peru, traveled to nearby market towns, and ended up at the famous Inca ruins via the Camino Salcantay, a high-altitude trail where well-appointed inns have opened a day's hike apart.

One of the two shots used on the opening spread of the article was a close-up of an indigenous woman selling textiles in the Indian village of Chinchero. "I arrived in the dark," Huey says. "I wanted to be there for the predawn light, before the sun touches skin, when there

are no harsh shadows and I can shoot [with the aperture] wide open. The sky then is like a giant, perfect soft box." A couple hours later, the buses arrived with tourists who then cluttered the scenes and occupied the vendors, making shooting more difficult. After the tour buses have left and late-afternoon light enriches colors, Huey will again take advantage of the quiet hours.

When assigned to shoot "Magic Carpet Ride," a story in which writer Donovan Webster set out to find the ideal Turkish rug for his office back home in Virginia, photographer Palani Mohan got some of his best shots at the Grand Bazaar in Istanbul. This covered market has some 1,200 shops and attracts a reported 250,000 shoppers daily. "Visually, it was an incredible place to shoot," Mohan says, "with lots of color and activities, and all sorts of people taking pictures." That worked to his advantage, because it meant the shopkeepers had become completely used to being photographed and, in any case, were too busy to complain.

TIP

Choose accommodations that reflect local culture and architecture. Tell the booking clerk you're working on a photo project and need a room with a view.

GO AGAINST THE GRAIN

Photographer Jim Richardson is apt to go to the small venues, in an approach that he calls "going against the grain." He has returned repeatedly to photograph Scotland and examples of Celtic culture, including the photogenic Highland Games sporting events. "I never go to the big Highland Games in Braemar, which the Queen attends," he says. "With all the security in place, you'll be stuck up in the stands. Instead I go to the small-town games, where I can walk out on the field where the guy is tossing the caber and hope that the caber doesn't land on me." As another example, when shooting the tiny but historic island of Iona, in Scotland's Inner Hebrides—which has only 110 residents but draws 130,000 visitors a year—Richardson makes a point of spending the night so he can be there after all the day-trippers have left. "When 4 p.m. comes, they're all gone on the ferry," he says. "The point is, whatever is the common way, go the other way," he says.

FIND AUTHENTIC ACCOMMODATIONS

Certain hotels and resorts have an endemic appeal, appearing as though they grew out of the natural

environment rather than replacing it. For an article on Bali, Justin Guariglia got both his lead photo (a spread) and the cover photo of that issue at the Begawan Giri Estate (now COMO Shambhala Estate), a lush tropical resort on the Indonesian island. "I saw people walking up and down outdoor steps taking baskets of flowers to guests at the water garden getting a massage," he says, describing a scene of utter paradise. "I spent an hour scoping out the best location to compose my shots and then spent half a day shooting." Guariglia advises, "Choose a place to stay that might render good images. In general, I ask for high floors to get a room with a view. I also tell the desk clerk that I'm a photographer wanting to take a great picture."

While shooting an article on southern India for *Traveler,* Michael Melford got two shots at Philipkutty's Farm that ran in the magazine. The palm-shaded property consists of a cluster of small villas situated on a backwater in Kumarakom, Kerala. "The area is like Venice," Melford says. "You get around by boat." He got a shot looking back from the bow of a boat, showing a boatman standing in the stern and poling along, with the inviting resort hotel in the background. "One of the guests needed to be taken to the other side of the waterway to hook up with a car," Melford recalls. "I went along to

Houseboats are an authentic lodging choice in Kerala, a southern Indian state popular with photographers.

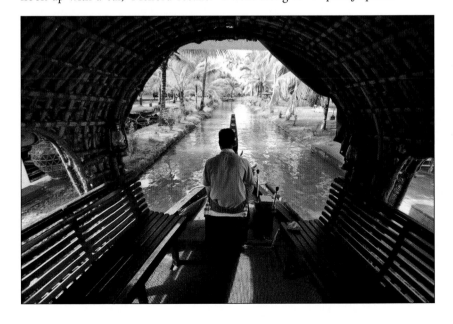

Authentic craftsmen, such as this Native American jewelry maker in Santa Fe, are almost always good subjects.

take pictures as the sun was coming up just after a rain." Another shot, equally intriguing, was of rainfall streaming into an open courtyard of the resort, where orchids grow from hanging coconuts. "Hotel shots can give you a sense of experiencing a place, of what it would be like to stay in that country," Melford says. Melford is quick to add, however, that some resorts—notably, the all-inclusive type—can sequester you in a decidedly inauthentic setting. "If you don't leave the resort compound, you could be anywhere in the world," he laments.

PARTICIPATE IN A RITUAL

Photographer Macduff Everton has found that respectfully participating in a local tradition or ritual helps you fit into a scene that you want to photograph. Everton and his wife went to Bumpari, a Himalayan mountain just outside of Lhasa, Tibet, to hang prayer flags on behalf of their daughter—a scholar who was working in the area and expecting a baby. "We feared something would go wrong," Everton says, "because she was living at Lhasa's high elevation, almost 12,000 feet."

Bumpari was already hung with countless colorful prayer flags. Monks and other pilgrims were there, making offerings. In the distance, rising over the valley, was Potala Palace, once the winter home of the Dalai Lama, sacred leader of Tibetan Buddhism.

"Our participation in the Buddhist rituals made it easier for me to take photographs," Everton says. "Whether you're photographing here or in a Roman Catholic cathedral, it's important to be observant and not act completely ignorant of someone else's traditions." The panoramic picture Everton got filled a double gatefold in *Traveler*.

SPEND SOME TIME, BUILD A RELATIONSHIP

Chris Rainier has photographed cultures around the world and has coached amateur photographers in doing the same. "I tell them the quality of the photographs is in direct proportion to the quality of the relationship." Sit down with an indigenous person at a campfire. Go with them to visit their family. Take a walk with an elder out into the fields. "That engagement opens up possibilities," Rainier says. "Even if you don't speak the same language, you can smile, laugh, give the thumbs-up sign." Take it further by learning a few words of the local language—Maasai, Quechua, Aborigine. "Even a little bit of engagement creates rapport," Rainier continues, "so that five minutes, ten minutes, two hours into the involvement, you can start getting photographs that go beyond the clichés."

Allow enough time for the relationship to happen, Rainier emphasizes. "Getting off a tour bus in a Maasai village and spending five minutes is one thing. Getting a cab or renting a vehicle and going back to spend the day is a completely different thing."

SHOW RESPECT AND HONEST APPRECIATION

Catherine Karnow has photographed Native Americans in the southwestern United States on numerous occasions, including Pueblo communities near Santa Fe, New Mexico. "I never go in shooting immediately," she

ESCAPING THE TOURIST TRAIL

Photographers have long fled the tourist trail in order to find authentic culture. Trouble is, the tourist trail is ever growing. Today, ironically, the remotest corners of the globe are where you're most likely to be *on* the tourist trail, while cities brim with vibrant neighborhoods, lanes, and shops that are rarely photographed.

says. "I may spend quite a bit of time in a community first, starting with the elders. You talk honestly about what your intentions are, but you also listen as much as you speak. I give them a sense that I'm a kind person who respects their culture. Then they might suggest you go spend time with so-and-so. So you go to that person, and it starts over again.

"You might start with an ordinary conversation about mundane things," Karnow continues. "I may sit and play with the children. I am honest to the point of appearing vulnerable, never domineering. I express my sincere interest in what they do and how they live. Only then, when the moment is right, do I ask if I can start shooting."

One way to break the ice, Karnow says, is to express honest appreciation of something that you want to photograph—some pottery, a person's home. Or Karnow will explain some difficulty she is having finding the right light or composition, to give them an idea of what she's trying to accomplish. "The idea is to connect human to human," Karnow says. "I'll say, 'Oh, this is really beautiful,' or 'I'm so honored to be here with you right now and to have heard what you told me earlier about your family.'" If the person appears to get nervous or uncomfortable, Karnow says, she'll come out from behind the camera and resume a gentle conversation.

For the *Traveler* article titled "The Color of Santa Fe," Karnow took a warm portrait of a Native American buffalo herder from the Nambé Pueblo. She initially met up with him so he could show her the buffalo herd, but after meeting him, she decided that it was his portrait she wanted most. "He was a quiet, shy man," Karnow recalls. "I was very nonaggressive." But by expressing genuine interest in him and his life, she found herself invited into his home, where she photographed him standing amid elk horns and other hunting trophies. "Ultimately," she says, "he was honored and validated by my interest in taking his picture."

THE LONG-TERM PROJECT

In the case of the Shaolin Temple in central China, birthplace of Zen Buddhism and the martial arts, it took

<table>
<tr><td>

TIP

"To be a great photojournalist," says Justin Guariglia, "you have to love people, to care about the culture you're shooting. Your sincerity and respect will help you to understand what you're trying to photograph—and will be obvious to the locals. As you absorb the culture, you become part of it. And that is reflected in your photography. Conversely, if you are insincere, that is obvious, too."

</td></tr>
</table>

Justin Guariglia five years—and Zen-like patience—to get access to photograph. "I came back many times over the years. Then one year, I went to the abbot directly. He had seen me; he knew who I was. I finally asked, 'Would you let me come in and photograph the monks on a very intimate level?' "

The result was a picture book, *Shaolin: Temple of Zen,* shot over three years, showing the monks of the Shaolin Temple practicing the meditative form of kung fu. An image from the book appearing in *Traveler* showed a monk performing a series of moves called "Through the Shoulder Fist." Such moves, rotely repeated, keep the monks fit and help them achieve a state of Zen. "The challenging part was composing the pictures with interesting backgrounds and capturing the fluid movements of kung fu in a still image," Guariglia says. Shi Yong Xin, the abbot, wrote the book's foreword, which included this line: "His photographs inspire a feeling of devotion toward the temple."

HIRE A FIXER

Few of us, of course, have five years to devote to gaining access to authentic culture. It's much quicker to hire a fixer, or guide. This is a key tip for photographers wanting to shoot pictures like the pros. A fixer can be useful

A Shaolin monk throws a punch at Justin Guariglia, who was working on a picture book at the Chinese temple.

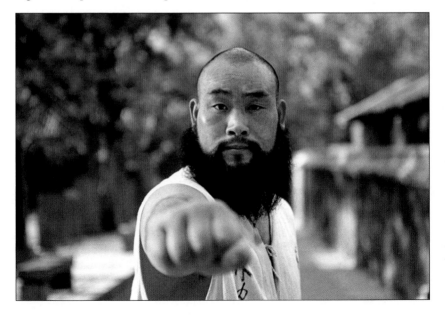

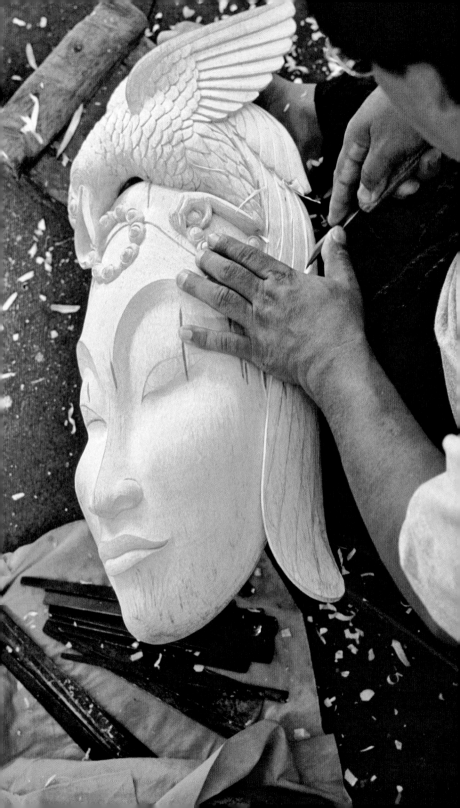

not just in developing countries but anywhere away from your home turf.

For the Bali assignment mentioned above, Guariglia called on an American expat living there to draw up a list of ceremonies and processions taking place during Guariglia's time on the island. "I had him book my room and hire my car and driver," Guariglia says. "I told him I wanted to go to the village that carves masks, the one that creates paintings." The fixer got Guariglia invited to a traditional Hindu wedding in the village of Mas, where he photographed a young couple exchanging vows.

"A fixer can take you to places that tourists normally don't go," Guariglia says. Some are highly coveted for their experience—and their names may be jealously guarded by photographers and film crews, shared only among close friends. Despite knowing Shanghai very well himself, Guariglia always relies on his trusted Shanghai fixer—whose name he won't divulge (see Chapter 6, "Capture a City").

Choosing a fixer. If you don't know a fixer in your destination, use a guide instead. (In Asia, Guariglia advises, choose a translator rather than a guide. Guides might steer you mostly to vendors offering kickbacks.) Start with your hotel concierge, who may know a good guide or might have a friend or relative who will take you around. Choose someone of the local ethnicity. "If I'm shooting in the Bronx," Guariglia says, "I hire someone from the Bronx. They'll know people, will speak with the right accent, will have the same background as the people I want to shoot."

What a fixer can do. Your fixer can get you under the skin, so to speak, of a location. For starters, they can take you to their own neighborhood, introduce you to their friends and relatives, show you the places they know and love. "My fixer in Shanghai took me to her father's tea shop," Guariglia says. "It was the most amazing place, with an incredible selection of teas. I spent half a day shooting there."

Fixers also help you avoid problems, says Michael Melford. "In a developing country, I always travel with a native," he says. "Not only do they have the language, but

For an assignment in Bali, Justin Guariglia hired a fixer who found a village for him that specializes in mask carving.

TIP

Even when hiring a fixer, take the time to do your own research and to draw up a shooting list. Then use the fixer to flesh it out and to work out logistics.

they know the customs. If you're about to do something that might insult someone, they will warn you. They become your best friend."

With a personal guide, Melford says, you're more likely to get out among the people, where good photographs await. On an assignment in Egypt, for example, Melford bypassed a Nile cruise in favor of reaching a destination by car with a guide and driver. "Ninety percent of the pictures I take are of what I see while walking or driving by," he says. While shooting in India for *Traveler,* Melford's guide led him to the Meenakshi Temple in Madurai. There he got an incredible photo of a woman in a colorful sari being blessed by an elephant who was placing its trunk on her head. The shot ran as a half page in the magazine. In general, Melford says, he never worries about where he's traveling—no matter how far off the beaten trail—as long as he's with his guide. "I never feel fear anywhere unless my guide is fearful."

Use a fixer of the opposite sex. Photographer Kris LeBoutillier recommends choosing a guide or fixer of the opposite sex, so that the two of you look like a couple. "It puts people at ease," he says. "You're not a single man or two guys, which can put people on edge, or a single woman by herself, which can be particularly difficult."

Sometimes photographers suspect their fixers embellish the truth to gain access but they appear to have a "don't ask, don't scold" policy toward the fixer. LeBoutillier, working on a photo book in Phnom Penh, Cambodia, wanted to photograph an alternative medicine procedure in which heated cups are placed on the skin to draw out bad humors. The fixer got him access to photograph the procedure for over an hour. "Later I found out that she had told them that I was a famous doctor from the States shooting for a medical journal," he recalls.

In another instance, LeBoutillier wanted to shoot the balconies of an old French colonial apartment building. To get the picture, he needed access to a private apartment in a building across the street. "I figured out exactly which apartment I needed to get into," he recalls. "The fixer and I knocked on the door, someone answered, and a lot of discussion in Khmer ensued." Soon the fixer motioned him inside. He had 15 minutes to shoot

from the balcony, and the resident even brought him tea. "Afterward, I asked my fixer what she had told him," LeBoutillier says. "She wouldn't tell me. It must have been such a lie that she was ashamed of herself." But, he adds, if you're serious about photography, "you've got to work with someone who can get you that access."

PREVISUALIZE AND MAKE ADVANCE ARRANGEMENTS

Visualize what kind of pictures you want before your journey, Chris Rainier advises, and make arrangements accordingly. "Chance favors the prepared," he points out. Six months before leading a cultural discovery tour to Jordan, Rainier might e-mail his fixer there, saying he wants a local woman dressed in traditional Arabic garb to meet the tour group in Petra. "The fixer will e-mail back and say what is possible, what isn't, and how much it will cost," Rainier says. "Then it's just a matter of getting off the plane and letting it unfold. It becomes a transaction in which everybody wins."

It was through his guide that Michael Melford discovered a temple in Madurai, India, where devotees are blessed by an elephant.

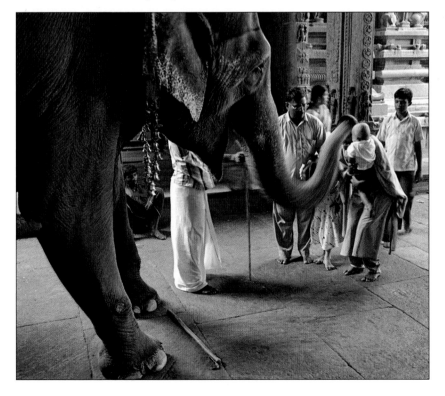

If you're using a travel agent to book a trip, let the agent go the extra mile to help you get photographs. "Tell them you want to stay a few days after the tour or you want to take an afternoon off, or ask if they can arrange to have a group of traditionally dressed Maasai meet you at the hotel." Rainier says. "Perhaps you've visualized photographing someone in a beautiful Indian sari at the Taj Mahal. You could simply show up and keep your fingers crossed and wait to see who passes by. My philosophy is that I may not have that much time, and I have to make it happen, so I'll work with a travel agent to set it up. Authenticity is still the key."

AUTHENTICITY IS NOT JUST FOR THE DEVELOPING WORLD

While it may be easier to find authentic subjects to photograph in, say, the highlands of Guatemala inhabited by the modern Maya wearing colorful textiles, you can also find subjects authentic to a place almost anywhere you go, even in large cities. Seek out the Paris bistro, for example, serving artisanal cheeses and natural wine, rather than the nearest chain restaurant. Look for a family-run jewelry shop in midtown Manhattan.

Talk to locals. The best tip, repeated by most of the photographers interviewed for this book, is to access local expertise by talking to people. "I don't use guidebooks when shooting for *Traveler,*" says Maine-based photographer David McLain. "They guarantee you'll wind up where everyone else is. Use a guide instead, or go to the local pub to chat people up. Everyone loves to talk about their home." McLain points out that Maine itself is a popular tourist destination, yet as a local resident, he knows where the uncrowded beaches are. "But the entire time I've lived here, no one has asked me about where to go in Maine."

Photographer Pete McBride used local expertise when shooting Ireland's capital for a *Traveler* article titled, ironically, "Dublin Without a Pint." He started out taking a "cheesy bus tour" of the city with the writer to get the lay of the land, but then he dug deeper. "I asked questions of everyone I met—hotelkeepers, local musicians, business owners. I asked them where were the best views, who pours the best pint, and so on. If you're friendly and show your interest, people respond.

COMPENSATION

Most *Traveler* photographers tip for pictures only if it's the established custom in an area. But increasingly, tour operators, working behind the scenes, are compensating members of traditional cultures for making themselves available for photographs or for putting on cultural demonstrations. When handled well, Chris Rainier says, that is an enlightened approach. "Out of fairness, there should be compensation," he says. "If I'm Maasai tending my herd, and someone says they want to spend time taking pictures, that time is worth something," he says. "It's a matter of treating humans as humans."

Bob Krist also prefers the arrangement in which the tour operator, rather than individual travelers, compensates local cultures. "In New Guinea, for example, individual tips are not part of their culture—and thank goodness, because it makes it an awfully pleasant place to work." Compensation gives the traditional culture a reason to stay traditional, he says. "Same thing in Peru. If giving some money for a picture to a colorfully dressed lady with a baby strapped on her back helps her live the traditional life instead of going to Lima and working as a hotel maid, then it's doing some good."

The most sustainable model, perhaps, is one in which the traditional culture itself is calling the shots. Rainier points to the Chalalan Ecolodge in Bolivia's Madidi National Park as an example. There, members of the Quechua-Tacana community run a jungle lodge and perform traditional dances (above), which Rainier photographed for *Traveler.* The arrangement sustains culture and gives visitors an authentic experience. But, again, Rainier says, the traveler must be sensitive to the level of authenticity, avoiding places where tourism has overwhelmed local culture. Otherwise, he says, you may end up photographing "Polynesian hula dancing on Waikiki Beach."

Many of them are proud of their home environment." Eventually, he found a pub that he liked, the Palace Bar, and returned several nights in a row, building a relationship with locals and shooting pictures there "from every which angle." A shot he took while standing on a bar stool, looking down on acoustic musicians playing their instruments around a beer-laden table, made it into the magazine.

BE BOLD

Despite the admonitions we give to be respectful and tactful, it's worth stating that sometimes you also have

While shooting a feature story on Dublin for Traveler, *Pete McBride returned repeatedly to the same pub to shoot the regulars.*

to be bold. For "The Last Real America," an article about rural eastern Montana, Aaron Huey shot a portrait of the Glasgow High School football team. The players were standing in line before the goalpost, hands over hearts, for the singing of the national anthem. The players were lit by stadium lights, and behind them was the waning sunset. To get the shot, Huey had to kneel in front of the team, in the middle of the field, noticeable to an entire stadium of spectators. "In a situation like this," Huey says, "I ask myself, 'How assertive should I be?' Then I remind myself that I'm a professional, and taking really good pictures can be uncomfortable at times."

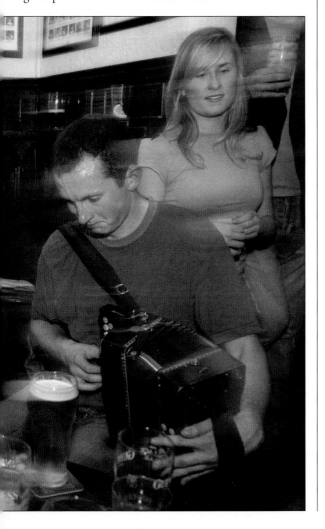

Chapter 5

Photograph People in Places

5 | *Photograph People in Places*

*Previous pages:
Catherine Karnow
captures a glance from
a local paysan while
shooting "In Search of
the Perfect French Vil-
lage" for* Traveler.

Traveler magazine is all about destinations, but as often as not our photographs feature people as subjects—the elephant driver in Sri Lanka, the potter in Morocco, the cocktail waitress in Phila-delphia—because people are interesting. Their manner, dress, and activities reveal as much about a destination as its architecture and topography. The ability to get good people shots is the mark of an accomplished travel photographer. Many travelers, unfortunately, are so shy about photographing people that they hardly try. Their fears are usually unfounded.

"I often hear before I go on a foreign assignment some dire warning that people in that country don't like to be photographed," says *Traveler* photographer Catherine Karnow, who has captured memorable people shots all over the world for the magazine. "My experience, with few exceptions, is that it's just not true. There are people everywhere who love to be photographed, if properly approached, and those who don't. It's an individual thing rather than [a] cultural [one]."

Professional photographers have learned to overcome their natural shyness in order to photograph people, and their techniques can help you overcome yours.

START WITH FAMILY AND FRIENDS

It's easy enough to photograph your traveling compan-ions. Go ahead and pose them in front of famous land-marks. But go beyond that obvious composition as well. Get shots of them engaged with the destination—shoot them looking out at the view instead of staring at you, or throwing snowballs over the rim of the Grand Canyon, or pointing at the Houses of Parliament while together you rise above the River Thames aboard the London Eye Ferris wheel. The idea is to shoot your loved ones doing something interesting in the foreground with the landmark in the background. Also use your traveling companions to lend scale to a shot. Photograph them strolling past a famous statue or fountain to give a sense of relative size.

PHOTOGRAPHING KIDS

Children, including your own, can make wonderful photographic subjects because of their natural curiosity and enthusiasm. But if you order them about like a drill sergeant to make your composition, they can quickly get bored with the effort. "The trick is to make it fun," says photographer Vince Heptig, who has been photographing young people for *Boys' Life* and *Scouting* magazines for more than 30 years. "You have to be a bit of a kid yourself," he says. "Engage them in something a kid

In Vietnam, a girl models an ao dai dress. "The pink scrolls in her shoes were drawings," says photographer Kris LeBoutillier.

would like to do—climbing something, making faces, eating. Don't just ask them to stand there for a pose. Be sensitive to when they are tired. Don't wear them out." Heptig shares another tip: If you get a good shot, show it to your young subjects on the back of your digital camera. "Once they understand what you're trying to do, they'll cooperate more," Heptig says.

For years, photographer Richard Nowitz photographed kids on assignment for *National Geographic World* magazine. "My secret is knowing that kids can get into pretending with you in a way that adults can't," he says. "One of the best examples was shooting a story about Warwick Castle in England being haunted. I had kids walk in under an archway at twilight, holding torches. I explained what I wanted, and they were able to have expressions on their faces showing both a sense of discovery and apprehension at the same time. It was perfect."

Amateurs often make the mistake of pointing the camera downward at kids, which compresses them, making them appear even shorter than they already are. Get down at their level to make a better shot. "Try different perspectives," says Nowitz. "But in general, get in close, shoot tight, and keep your backgrounds clean."

SHOOTING STRANGERS ON THE SLY

An easy way to start photographing strangers is to include them in compositions with your traveling companions. Shoot a loved one buying a weaving from a street vendor or haggling with a merchant in a marketplace. At times, you can appear to be pointing the camera at your companion while surreptitiously photographing someone else. Also use this ploy while ostensibly photographing an artwork or monument but actually focusing on someone standing or seated nearby—say, a guard or docent in a museum.

COUPLES ADD WARMTH

A likely way to get an intimate photograph is to shoot a couple. When Catherine Karnow encounters couples working together at a destination—say, shopkeepers, or bed-and-breakfast owners—she'll say to the wife, "Can you come in and put your arm around him?" Or it might be two friends, or a grandparent and grandchild. "I'll ask them to touch each other. The result can be a very gentle and harmonious composition."

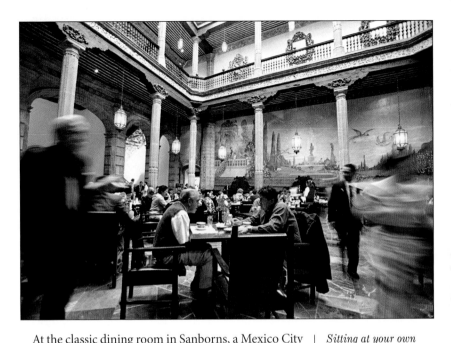

At the classic dining room in Sanborns, a Mexico City department store housed in a 16th-century building, *Traveler* contributing editor Macduff Everton pretended to be photographing his wife, Mary, while actually focusing on gentlemen at a nearby table. "The restaurant was full of activity," he recalls, "and no one paid any attention to us." The resulting picture filled an entire spread in the magazine.

Sitting at your own table in a busy restaurant is a good vantage point for taking people shots surreptitiously.

CAPTURING PEOPLE ON THE JOB

Photograph people while they're doing what they do for a living. Start with people whom you naturally encounter as a traveler—the cabdriver, waiter, tour guide, bartender, shopkeeper, hotel desk clerk, or vendor. "People are proud of their work and are often glad to be photographed," says Singapore-based Kris LeBoutillier, who has shot assignments for *Traveler* in India, Vietnam, and Tasmania. "That's frequently easier than photographing them in a private moment, while eating, for example, or reading a newspaper." Get to their places of business—say, a market or shop—early in the morning, while locals are shopping and before tourists have arrived. In Tasmania, LeBoutillier approached a vendor of organic jams in a marketplace with his camera down at his side. "I chatted with her about her jams, tasted

some jam, and only then got around to asking her if I could take a picture."

One memorable people shot Everton took for *Traveler* was of a street barber cutting a young boy's hair in Beijing. Before shooting, Everton got permission (speaking through a translator) from the boy's grandmother, who stood nearby. "She told me it was the boy's first haircut," he recalls. "The grandmother was proud—and happy to have him photographed."

Austin-based freelance photographer Will van Overbeek got a great people shot while on assignment in London by staking out a busker (street musician) at work. Overbeek was hoping for a shot showing what a melting pot London had become. "I came across a Scottish busker playing the bagpipes for tips along Oxford Street, a fancy shopping district. I tipped him for his music, asked if I could take his picture, and then waited. Soon an Arab family stopped to listen, and the woman was completely veiled in black—a stark contrast to the piper in his kilt. That was the conjunction of cultures I wanted."

TIP
Buying from a vendor will get you better cooperation in return. Bob Krist gives the bought item to someone else, who becomes his next subject.

MAKE THE MOST OF FESTIVALS

Festivals, parades, and similar events offer an ideal chance to photograph people at their most colorful and at a time when everyone expects to be photographed. *Traveler* photographers preparing for an assignment do well to pore over the local calendar to find such events. "If you can have a festival or two in your back pocket," says Jim Richardson, who has shot extensively for *Traveler* and *National Geographic,* "you know you can get your good people pictures."

For example, Richardson found the Festival Fringe in Edinburgh, Scotland—among the world's largest arts festivals—a rich hunting ground, full of street performers, musicians, acrobats, and all manner of people in costumes. In one memorable shot, he asked an acting troupe in makeup to climb a hillside with him so he could use them as the foreground in an overview shot of the city. His shot of a young boy in a marching band uniform, looking amusedly at a man nearby dressed in drag, made for an unforgettable spread. "I had to position myself just right—getting down at the boy's level—so that the two of them were of similar scale and

Kris LeBoutillier arrived early at the Salamanca Place Market in Hobart, Tasmania, where the jam vendor was happy to pose for a picture.

TIP

Determine which of your lenses works best for portraits. Some photographers use a wide-angle or mild telephoto. Kris LeBoutillier prefers a 50mm f/1.4 prime lens. "It gives me a shallow depth of field so I can easily blur the background," he says. "And it allows for either a tight or loose composition without the distortion of a wide-angle lens."

there would be an interplay between them," he recalls.

While photographing Tasmania for *Traveler*, LeBoutillier stumbled onto an Anzac Day parade in the city of Hobart. "It's their equivalent of Memorial Day," he says. "It was a big parade of veterans with everybody coming out. I got some great shots—totally by luck. I had been so obsessed with looking at the map that I'd forgotten to look at the calendar." His shot of young girls waving flags made it into the magazine.

APPROACHING STRANGERS

Photographing strangers on the sly, on the job, or at festivals gets you only so far, of course. To get the shots she wants, Catherine Karnow is prepared to approach total strangers on the street. Over the years, she has fine-tuned her people skills to get optimal results in such situations. "To begin with," she says, "I'm always conscious of how I come across. I dress tastefully, with nice shoes, not sneakers, so that I look pleasant and professional, never sloppy. I don't wear shorts unless I'm on the beach. I try to be inconspicuous, not intimidating," she continues, "so I don't carry around big packs full of equipment."

Karnow has developed a radar for reading people. "I'll act differently toward a gay guy, an older woman, a middle-aged man, or a young girl," she says. "But it's almost always effective to smile and be nice. I often start by giving an honest compliment: 'I love the way you look in that suit. Do you mind if I take your picture?'" Once the subject has consented, she will engage the person in chitchat (even if through a translator) while photographing, trying to get them to smile, to laugh, to be at ease. Simultaneously, she's constantly thinking how to make her composition better. After she's broken the ice and taken a couple shots, she may ask the person to face a different direction or to take a few steps this way or that, expressing her enthusiasm for how the shots are getting better.

If the stranger is cooperative, as usually turns out to be the case, Karnow is ready to make the most of the situation. For a *Traveler* feature titled "Insiders

Miami," Karnow hung out in a funky clothing store and approached a couple of young women browsing the merchandise, hoping to picture them in the most colorful scene possible. "You start off slowly," she says. "After greeting them, I asked if I could shoot pictures of them looking through the racks. Simple enough. After a while I asked if one wouldn't mind holding a dress up against herself for me to shoot. You reel them in one step at a time. 'How about standing in front of the mirror with that?' 'Oh, look, wouldn't that scarf look nice on you? Wow, you look great!'

"Make the person happy," Karnow continues. "Keep them entertained. Try to have a good time with them," she says. "It's like keeping a balloon aloft at a party. Keep everything upbeat while you get what you need. Before long, I had them trying on dresses that I picked out. They were totally into it." And one of the shots made it into the magazine.

Macduff Everton has found it effective to approach someone who has a pet. "Love of pets is universal," he says. In Beijing, for example, Everton noticed that many people kept birds in small cages and would take the cages out during walks. He approached one such bird walker, pointed to the cage, pointed to the camera, got the nod, then got the shot—not just of the bird, but of

Show subjects your pictures to raise enthusiasm. The digital display screen has largely replaced the Polaroid print for this purpose.

Preceding pages:
By strolling a few
blocks off the busy
Piazza Navona in
Rome, Bob Krist
found these gents
playing chess in
a backstreet.

the pet owner and other strollers around him. The picture captured a sense of street life in Beijing. "I didn't have a translator with me," Everton recalls. "I made myself understood with hand gestures. It's amazing how cooperative people will be if you make any little effort to communicate."

GRATUITIES

In some heavily visited areas, locals may ask for money to be photographed. Use your own judgment. *Traveler* photographers rarely shoot in those situations, because the subjects can be artificial, often dressing and behaving a certain way specifically to attract photographers. Furthermore, tipping can set a bad precedent. If one photographer tips, then the next photographer will be asked to tip as well.

But in some situations, doing a favor for the people you photograph seems completely reasonable. Some *Traveler* photographers used to carry Polaroid cameras to give out instant prints. That's trickier in the digital age. "I was recently shooting in the Yucatán," says Everton, "and I found that even small towns there have one-hour photo developing, so I was able to get some shots printed off a memory card and take them back to the people I'd been photographing. I never promise to give out pictures unless I know I can."

Can't give prints? Then at least show your subjects the picture on the camera display screen, says Michael Melford. "Especially in developing countries," he says, "I always show them the picture right away. It lets them know what I'm up to. They become more engaged in the process. If possible, later I will e-mail them some shots."

Photographer Bob Krist says it's OK to tip where that's already the norm. "For example, in the Inca Valley of Peru," he says, "the colorfully dressed people will happily pose for you but they want a sol, worth about 30 cents. That's the going rate. But if tipping is not part of the culture, then you shouldn't start it."

Krist's strategy for shooting in indigenous markets involves buying some food items from an interesting vendor, "which makes them more amenable to being photographed," he says. Then later he gives the

TIP

Enhance your portraits with appropriate props. To shoot this chef in Provence (opposite), Catherine Karnow styled a basket of herbs picked in the woman's garden.

THE ENVIRONMENTAL PORTRAIT

The "environmental portrait," which shows a person in his or her surroundings, is a mainstay of travel photography and is frequently used in the pages of *Traveler*. Catherine Karnow is a master of this kind of portraiture. She often uses a tripod and cable release so that after composing the picture, she can step out from behind the camera and sit closer to the subject to put the person at ease. She'll typically select a fast lens and set a wide aperture to blur the background. One type of portrait she goes for is the serious, "fixed gaze" picture. "I'll ask the subject to devote their entire attention to the camera for the next few minutes, ignoring all distractions. It's like I'm hypnotizing them," she says. "I tell them there's only you and me and the camera and nothing else in the world. I want to look deeply into their face and capture the mood of the place," she says. Other times she goes for a joyous portrait, with the person smiling or laughing. For that, she'll engage the subject in conversation and might even include a third party to keep the conversation lively. "We'll be joking, laughing, talking small talk," Karnow says, "but all the while I'm intensely scrutinizing the subject, snapping the cable release at just the right moments, trying to get what I want." Karnow offers this important insight: "The person will tend to mirror your mood. If I want a serious picture, I act seriously. If I want joyful, I laugh and smile. I don't tell the person what expression to have. I evoke it from them through my own behavior."

food away to a child or mom on the street, getting their picture, too. "I get a picture at both ends of the transaction," he says.

ALLAYING FEARS

Jim Richardson points out that photographers have to overcome not only their own shyness, but also the nervousness of the people they want to photograph. "Don't be a spy," Richardson says. "People know you're there. Put away the zoom lens, cross the street, and go meet the person you want to photograph. Let them know what you're doing. The psychology is that they are naturally afraid that you may want to portray them in a bad light. Try to allay that fear. Let them know that you like what you see. Wandering the streets and pointing the camera at people without talking to them is fraught with anxiety. The easier way to photograph people is to befriend them

first and then take the picture. That makes the encounter into a rich and rewarding experience.

"There's no one best way to approach people," Richardson continues. "Your approach will depend on your personality. The important thing is to develop a technique for gaining people's trust."

Taking the bold step of approaching strangers can open doors that would otherwise be closed. As Everton recalls, "I was teaching a photographic workshop in Mexico. I gave the students an assignment to photograph a local person, with the stipulation that they had to talk to the person, even if they couldn't speak Spanish. The students were amazed at what happened. Their subjects often collaborated with them and took them, in some cases, to better scenes to take the shot. Some students told me the exercise changed how they would shoot for the rest of their lives."

A farmer harvests her crop in the Yunnan Province of China. Jim Richardson says each photographer has to develop a technique for earning people's trust.

Chapter 6

Capture a City

6 *Capture a City*

Previous pages:
John Kernick shot
this high—but not
too high—view of the
Manhattan skyline
from the 65th floor of
the GE Building in
Rockefeller Center.

Increasingly, cities are not just where people live and do business, but also where we travel on vacation. And why not? Cities have it all—culture, history, dining, shopping, recreation, entertainment, nightlife, and a circus of interesting people. That appeal is obvious in *Traveler* magazine. Each issue has multiple feature spreads celebrating the Bangkoks and Barcelonas of the world as well as additional urban glitz in our City Life department.

Travelers may love cities, but photo editors often do not. Cities are tough to shoot, and these assignments are reserved for our most accomplished photographers. Even then, there's the constant fear that the coverage will be somehow incomplete, failing to capture the city's essence, which (as they say about obscenity) is something you can't necessarily define, but you know it when you see it. So after the photographer's "take" comes in and the staff assembles in the darkened conference room to review the selects projected on a screen, the atmosphere is tense. The picture editors hold their breaths and cross their fingers, even more so than usual, fearing the editor in chief's dreaded sigh of disappointment.

TIP
Before arriving, make a shooting list. Map out a logical route linking your subjects.

"Cities are complex—the most difficult assignment," says photographer Justin Guariglia, who shot "Buy, Buy Shanghai," the cover story for a special issue on cities. "The options before you can be so overwhelming that you end up with an underwhelming set of pictures."

DON'T LEAVE IT TO CHANCE

The key to a successful city shoot is to have a strategy, a plan of attack, instead of leaving everything to chance. Start with a shooting list (see Chapter 1, "Get Inspired"). "When I shot 'Found in Translation,' a feature story on Tokyo written by *Traveler*'s editor in chief," Guariglia says, "I had six million interesting possibilities, so I had to prioritize." A shooting list reduces your anxiety about getting the job done. Instead of feeling overwhelmed, you feel empowered and on task. Guariglia breaks down

his list—a dynamic document based on pretrip research and then refined in the field—into the A list, B list, C list, and so on, with the most interesting possibilities at the top. He still leaves room for serendipity, however. "When I'm there, I'm constantly talking to people—the concierge, the waiter, anyone I meet. I flip through books in local stores, postcard racks, whatever might give me ideas about subjects and viewing angles."

Catherine Karnow is the queen of *Traveler* city assignments. She has shot more cities for us (including Paris, London, Budapest, and Sydney) than any other photographer. Like Guariglia, she'll do pretrip research and confer with the writer to see what will be emphasized in the text. But then, almost like an urban sociologist, she organizes her strategy around capturing major elements of city life: people (young, old, trendy, famous), architecture, dining, shopping, history, the arts, entertainment, nightlife, sports, transportation (rail, boats, cars), and icons. There's no one right strategy, of course. Just having a strategy is what matters.

CATCH THE PULSE

The next step is a very practical one: Break down the shooting list by day of the week—and even by time of day—so you know what you should be shooting and

Neon lights reflecting off a taxicab heighten the vibrancy of this shot by Justin Guariglia of Tokyo's bustling Shinjuku district.

when. "Different parts of a city are active at different times of day," says photographer Kris LeBoutillier. He shoots markets in the morning, parks at the lunch hour, and the theater district at night. "Lots of cities are situated on bodies of water," he adds, "whether a lake, a river, or an ocean. People like to congregate near the water. You want to go where the people are."

Karnow likes to shoot trains in the morning, romantic scenes at dusk, and interior shots—say, in restaurants, shops, or galleries—at midday, when the sunlight is harsh. "In general, go inside during the brightest hours,"

she says. "However, street scenes in districts with very tall buildings might best be shot at midday, too, because of interesting reflections coming off the glass. You often can't shoot there late in the day because of the canyon effect, with streets hidden by dark shadows."

In large, sprawling cities, be mindful of distances and transportation options when scheduling your shoots. Use subway and street maps, or a GPS, to plan your route. Make your movements efficient so you don't waste time crisscrossing the city. "It can take hours to get across Tokyo," Guariglia notes.

Shooting a nightlife scene in Paris, Catherine Karnow captured smiling faces around a table in a crowded nightclub.

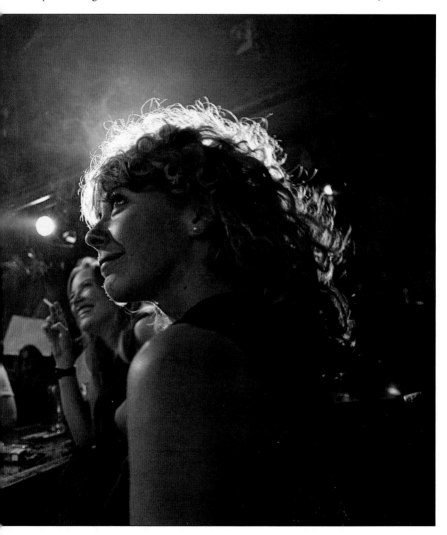

SCOUT AND GO BACK

You've refined your shooting list and set your schedule and route. Now what? Professional photographers know that they might end up spending an hour working just one scene, so they want it to be the right scene. For the sake of efficiency, many will spend the first day of an assignment scouting out the highlights on their list, taking a few shots but knowing that they'll return later to do the real work. This takes out some of the randomness that can spoil a city shoot. Imagine spending two hours working scenes on 16th Street only to discover later that the real composition you wanted was on 17th.

"Despite all my advance work," says Karnow, "when I arrive at a city, I really don't know what most of it looks like. So I very purposefully scout every location on my shooting list. During this process I take scouting pictures, snapping away, which I can look at later. I determine which places are photogenic. In the case of hotels and restaurants, for example, I'm looking for natural light, interesting decor, whether the place has a certain flavor or style. When I shot 'Authentic Paris' for *Traveler*, I went to every place on the list—including ten different restaurants that the writer had identified as the most interesting in the city—and crossed off three out of

It was on her fourth visit to the same cricket ground in Bombay that Catherine Karnow got her favorite shot, of players stretching.

every five of them as not promising. That left me with the ones most visually exciting."

RETURN AGAIN

Another professional technique is the willingness to work a location repeatedly. While shooting London, for example, Karnow returned evening after evening to photograph rush-hour traffic swirling around the Royal Exchange building at dusk. "I kept adjusting my composition, moving a few feet this way or that, to get the best view of this mad fury of vehicles."

Subsequent visits can also help you get beyond the obvious shots you take early on. "In Bombay," Karnow says, "I returned to a cricket ground four times on a ten-day assignment. The first few times I photographed the boys playing the game and exercising. But on my last visit I started finding more subtle, beautiful photographs. The place starts to unfold before you, to get inside you. My favorite shot ended up being of these four boys just stretching. It was like working on a painting or sculpture. You refine it over time. You add layers. You take away layers. You form it. You're not just snapping. People don't understand this. They expect the picture to happen fast. They might ask me, 'Why are you here for so long?' "

Of course, eventually, it's time to leave. "It's like when you're in a theater and the movie ends and the lights come on," Karnow says. "Suddenly the magic spell you've been shooting under—enthralled by the picture possibilities—disappears. You realize there's nothing more for you to see."

REVEAL THE SEASON—OR NOT

Some cities look particularly beautiful in fall or winter, but the best time to shoot, generally speaking, is in spring or summer. At *Traveler*, we don't always have time to plan a story a year in advance, meaning our stories will often be shot off-season, due to the long lead time of consumer magazines. We want most stories to be publishable year-round. Very rarely do we do snow stories, because they lock us into using the article during only one of the four seasons.

TIP

Your compositions should be strong and uncluttered, but also strive to have a depth of content in a single image. "Try to kill two or more birds with one stone," says Catherine Karnow. A picture of cricket players in Bombay, for example, not only reveals a popular local sport but also says something about India's British colonial history.

TAKE THE BIG PICTURE

One shot you'll see in every *Traveler* city story is the overview, or establishing shot. It might be a skyline or some other sweeping perspective that answers this simple question: "What does this city look like?" It's an obvious shot that many amateurs don't bother to get at all. The hard part is making it inspirational and not just informational.

"The best views for the eyes often don't make good photographs," Karnow says. "I rarely bother with views from the tops of mountains, for example."

Overview shots that make it into *Traveler* usually offer a novel perspective, and that means extra legwork. For "French Twist," a feature article on Montreal, Karnow found a skyscraper that had an open-air rooftop bar 45 stories up. She managed to find a perch above head level from which to shoot. Her composition had the cityscape in the background, complete with the St. Lawrence River, and a vibrant people scene in the foreground. "I look for drama," Karnow says of overview shots. "Something interesting has to be happening close to me, with the cityscape often a secondary element."

Indeed, rooftop restaurants and bars—which are open to the public—offer ideal vantage points. When shooting "Strip Tease: The Insiders Guide to Las Vegas" for *Traveler,* Will van Overbeek found his overview shot on the 64th-floor Mix Lounge at the hotel at Mandalay Bay, which purportedly offers the best views of the city. To add interest, he captured a cocktail waitress in the foreground, crossing a floor lit from beneath with spiraling red lights. She was slightly out of focus, whereas the cityscape was sharp. "That shifted emphasis to the real subject of the picture—the city," van Overbeek says.

Of course, *Traveler* photographers will take advantage of natural overlooks as well. In Budapest, Karnow went to Castle Hill for a popular viewpoint looking across the Danube to the Pest section of the city. She ramped up the interest level by waiting to capture a couple embracing in the foreground. "In this case, I got lucky," she says. "The embrace happened so fast."

Previous pages:
Bars, restaurants, and hotels located on the high floors or roofs of tall buildings are good locations for shooting city overview shots like this one of Montreal.

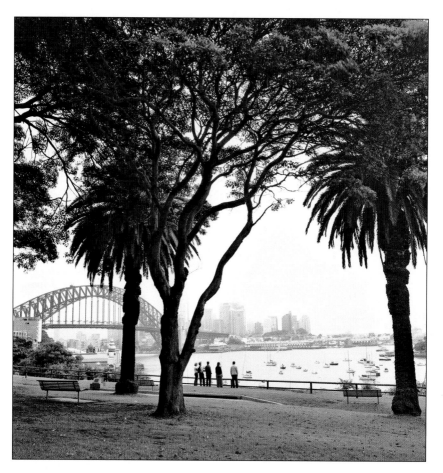

BRING TIRED ICONS TO LIFE

Besides overview shots, or sometimes within them, *Traveler*'s city coverage often includes famous landmarks or icons. But how does a *Traveler* photographer distinguish his or her Eiffel Tower or Golden Gate Bridge from the countless other examples already published? For Karnow, again, the answer is to bring an interesting foreground into the frame, making the shot into a scene rather than a static landscape.

"You definitely have to shoot icons, something the city is famous for," Karnow says. "But I'm constantly trying to find a way to make the picture interesting to me."

For a feature story called "Insider's Sydney," the icon in question was the Harbour Bridge, as famous among Australians as the Brooklyn Bridge is among New Yorkers. Karnow wanted to go beyond the usual bridge shot

As this shot of Sydney's Harbour Bridge shows, the landmark itself needn't always be emphasized in a landmark composition.

with the Sydney skyline in the background. She cruised the waterline until she found a city park full of locals with the bridge behind them. "The shot showed people enjoying their city, with the famous bridge just part of their everyday lives." Her picture revealed something very appealing about life in this oceanside city full of parks and public beaches.

In the case of Montreal, a city with few landmarks well known outside the city, the icon Karnow set her sights on wasn't a structure at all but rather the famed performance troupe based there, Cirque du Soleil. The usual tack would be to shoot the acrobats at a performance, but none were scheduled during her assignment. So Karnow ventured to the troupe's training studios, only to be disappointed. "They weren't wearing makeup or costumes," she recalls. "It just wasn't exciting. I knew I had to switch gears." Karnow discovered that, even as she stood there, worrying about her shot, a few of the performers were appearing in a charity parade downtown. So she fled the studios, rushed to the scene, and found costumed troupe members darting in and out of the crowd of spectators. The shot she got—of two white-faced imps teasing businessmen on a busy sidewalk—became the opening spread of the article. It was a fresh, never-before-published view of a well-publicized subject. It also happened to reveal Montreal's dual nature—as a serious business city that loves the arts.

Likewise, Austin has a nice enough skyline, but it's the city's funky music scene that's really iconic. To capture it, van Overbeek went to a classic honky-tonk, the Broken Spoke, where he shot proprietor James White, in yellow cowboy boots and a Western shirt, introducing musician Alvin Crow before a performance. What really set the picture apart was the foreground. There, out of focus, was "Cowgirl Heidi" rolling a wagon wheel—with broken spokes—around the dance floor in a time-honored ritual. The picture filled an entire spread in *Traveler*.

Few icons have been photographed as often as the Taj Mahal in India. But *Traveler* photographers still find ways to get fresh shots. (That is, after all, what we pay them for.) For our original "50 Places of a Lifetime" special issue, we ran a shot by Steve McCurry with the

famed 17th-century mausoleum appearing only as a reflection in the Yamuna River. A wader was dipping his hand into the water, creating faint ripples near the reflection of the Taj Mahal. The picture was not only unique but by most measures a work of art.

Another *Traveler* photographer, Macduff Everton, got his own unique images—dramatically different from McCurry's—arriving before daybreak on a winter day while mist was still floating in from the river. Everton boldly cropped out the most striking features of the Taj Mahal—its domes. Yet the majesty remained. "This is a view most people haven't seen," he says, "but you still know what it is." Everton arrived early and took his shot around 8 a.m., when there were enough people present to lend scale without overrunning the scene. "As the fog burns off," he says, "it makes the morning light luminous rather than harsh."

MAKE BUILDINGS SHINE
Local architecture is an important part of any destination, but building shots tend to be dull. A dependable remedy, once again, is to compose with a compelling foreground element. When Karnow shot the Notre-Dame Basilica in Old Montreal, she made sure people were in the

Steve McCurry found novel ways to shoot the Taj Mahal. This shot shows a boy dipping water from the Yamuna River.

foreground, and for even more interest, she clicked the shutter just as a flock of pigeons was exploding into the sky. "It's not the building but what's going on in front of the building that creates interest," she reiterates.

One of van Overbeek's favorite foreground subjects is other photographers. When shooting the famous fountain show at the Bellagio Hotel in Las Vegas, he found a vantage point behind the spot where a group of adoring tourists was shooting the scene. "In general, people try to be polite and duck out of the way when I'm shooting, but I don't want them to. They're what make the shot."

Tilting a camera upward to shoot a building can result in a distortion effect known as converging parallels, or keystoning. You can step in close to exaggerate this on purpose—so that the stately pillars in front of an old courthouse, for example, appear to lean toward each other. But more often you'll want to minimize the distortion by shooting the building straight on, perhaps from partway up a facing structure. Other fixes include shooting just part of the building or turning the camera to shoot vertically instead of horizontally.

As in so many other situations, the best light for shooting building exteriors comes during the "magic hour" (the first and last hours of daylight). Ideally, you should balance three light sources: skylight, light from streetlamps, and lights from within buildings, says photographer Richard Nowitz, who has shot countless buildings for travel guidebooks. "You want to shoot the building when everything is glowing," he says. "Architecture isn't terribly interesting in the middle of the day."

When shooting in low twilight, Nowitz will steady his camera however he can, whether with a tripod or monopod or just by bracing his camera against a wall. To try to further cancel motion, he'll shoot a burst of

CARRY A TRIPOD

A tripod helps Catherine Karnow get three types of shots: When shooting food or detail shots, she positions the elements, checks the composition through the stationary camera, then tweaks the arrangement until it's just right. When shooting a portrait of someone who seems nervous, she can step out from behind the camera to interact more comfortably. When shooting in low light or at night, the tripod helps avoid motion blur at slow shutter speeds.

three pictures at once. "The first shot is blurry, the second is sharp, and the third is even sharper."

STREAK THE TAILLIGHTS, SHOOT THROUGH WINDOWS (BOTH WAYS)

Add interest to a building or landmark shot with streaks of red created by the taillights of vehicles driving past. Experiment with different shutter speeds. Karnow, who used this technique while photographing the historic Chain Bridge in Budapest, typically shoots taillight scenes in slow traffic at 1/8 or 1/15 second, with her camera set on auto exposure, shutter priority. This is slow enough to create streaks but fast enough for some definition. "I like to have the streaks broken up," she says. "I don't like a continuous line of red. And I want at least one car in sharp focus."

She added even more interest to the composition by framing the shot with her hotel window, which imparts

When booking a hotel room, always request a room with a view. Catherine Karnow did—and got this bridge shot in Budapest.

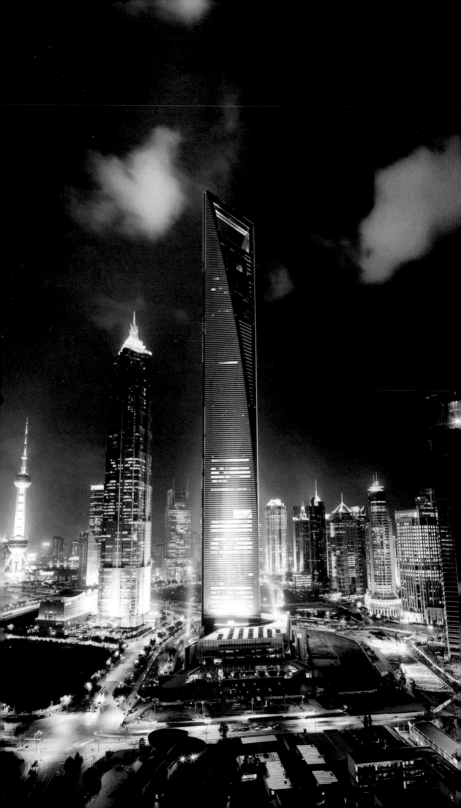

the sense of experiencing the view as a visitor would. "I requested a room with a view of the bridge," she says. "It's what I saw every time I walked in. I became obsessed with it, shooting it every which way. The shot turned out very romantic," she says. It was, indeed, a multilayered treat, with the window as frame, the bridge, the taillights, and even some elements of the cityscape lit at dusk in the background.

Van Overbeek describes how to shoot through a window the other way—into a building, rather than out of it. "If the glass is clean, you can press your lens flat against it, and the window disappears," he says. In direct sunlight, he adds, cup your hand around the edge of the lens to reduce glare. Or back up a bit to capture not only what's inside the window, but also some reflections of what's going on behind you. "For example, you might shoot through a store window at an interesting display but also capture a street scene in the reflection." Another window strategy is to go inside a store and shoot out past the window display at people looking in. "I did this at a bakery in France," van Overbeek says. "I shot people admiring a display of cakes. It was a great picture that only cost me the price of a cookie."

A fixer helped Justin Guariglia find the right place to shoot a novel composition of Shanghai's glitzy Pudong district.

TIP

The best "night" shots are rarely taken at night, but at dusk, when there's still enough light in the sky to help illuminate a scene.

FIND THE NOVEL SHOT

Cities—all cities—have been photographed extensively. And in the age of the popular photo-sharing website Flickr, countless shots of practically any given city are as close as the Internet. Stock agencies offer many thousands more, shot by professionals. So how does a *Traveler* photographer like Justin Guariglia tackle a city like Shanghai, which, at this writing, appears in more than a million compositions on Flickr alone? "In general, if the scene has been photographed to death, I'll avoid it," he says. "If it's unavoidable, such as the skyline of Pudong [Shanghai's high-tech business district], I'll come up with a new angle, something fresh, so it's worth the magazine's expense of sending me here and not just using stock pictures."

In the case of the Pudong skyline, that was easier said than done. Most compositions of Pudong are made from across the Huangpu River along the Bund, the

popular touristy section of Zhongshan Road. "Thousands of people have made that shot," Guariglia continues. "I can't come back with that. My job is to bring back a view of the city nobody has photographed before."

Guariglia's secret weapon was his fixer, or guide (see Chapter 4, "Seek Out the Authentic"). "I sent her out to find what I wanted—a composition not from ground level or too high up, of the city glowing, just after all the lights of the skyscrapers came on. A day later she returned with the perfect site. She showed me pictures she took with a point-and-shoot."

The vantage point was a private condo in a high-rise complex that she found with the help of a real estate agent. The balcony had a startling view of Pudong's iconic skyscrapers—the bulbous Oriental Pearl Tower, the pagodaesque Jin Mao Tower, and the Shanghai World Financial Center, housing the Park Hyatt Hotel. "My fixer said the agent would take me back up to the apartment for a tip and that he knew I was just a photographer." Later, when the weather conditions were right, the fixer brought Guariglia to the condo complex, where the photographer sensed something was wrong. A different real estate agent arrived, followed by the owner of the apartment. "They expected me to buy the place," Guariglia recalls. "I could've strangled my fixer." Instead, he played along, feigning interest in the property so that he could get his shot.

TIP
If you don't have time to scout all the locations on your shooting list, send a fixer out to shoot scouting shots for you.

The story doesn't end there, however. The view from the condo wasn't perfect after all, Guariglia realized. He had to get to the roof. "I was racing against time," he says. "There's a 50-minute window when the dusk light is just right and a 15-minute sweet spot after the building lights come on. When I reached the top of the stairs, the hallway was dark, and all the doors locked. I pulled out my flashlight and found a partially opened window. I pried it open and stepped out onto a deck." From there, with just minutes to work, Guariglia got his shot. A lot of trouble for one picture, yes, but it was so striking and unusual it made the cover of *Traveler* magazine.

BE RESOURCEFUL

As the above anecdotes illustrate, much of good travel photography hinges not just on clicking the shutter at the

THINK ON YOUR FEET

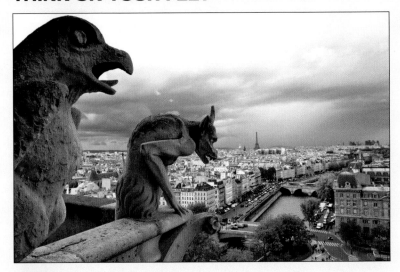

When it comes to getting access, remember this motto: "It never hurts to ask." Is an area roped off? Does a sign read "No Visitors Beyond This Point"? Ask anyway. The worst that can happen is that you're denied—and surprisingly often, you won't be. "As with photographing people [see Chapter 5, "Photograph People in Places"], always start with a compliment," Catherine Karnow says. "Tell the official how beautiful the establishment is and that if only you could get up to the balcony, you could shoot the perfect picture."

A related maxim is "Think on your feet." One day during her coverage of Paris, Karnow noticed a particularly dramatic sky, with brooding storm clouds broken up with sunlight and patches of blue. "The clouds were moving quickly. I started running around looking for things to shoot." The iconic Notre Dame Cathedral was not on her list, but she happened upon it, noticing long lines of tourists waiting to get in. A special permit, she discovered, would grant her access to areas closed to the madding crowds.

"I was told that a full-day permit would cost $1,200, and a half-day $600, so which did I want?" Karnow replied that a full day was beyond her budget, but she would need to scout the restricted areas up on the tower walkways in order to decide whether to come back in the morning or afternoon. Agreed. When a guide took her up, "I started seeing all these pictures," Karnow says. "My hands were shaking because it was so amazing." Karnow told her assistant to keep the guide occupied as long as possible. "We managed to stay up there for two hours, and I got what I needed." Her "scouting" picture—of Left Bank rooftops, the Seine, and the Eiffel Tower in the distance with a stormy sky framed with a Notre Dame gargoyle—fills the first spread of a *Traveler* feature story.

right moment, but also on the sometimes laborious—or clever—maneuvering needed to get into position. While the amateur relies on happenstance, the professional is often purposeful and calculating. Guariglia follows his shooting list like a soldier with marching orders. But he knows it's just the beginning. The real work is in bringing the listed attractions to life.

When Guariglia arrived in Perugia, the Italian village that *Traveler* was billing as the "World's Sexiest Small City," he was delighted to find it manageable in size—a nice change from Shanghai and Tokyo. He spent a day exploring, checking the sites on his list, and adding others. "You can walk from one side of Perugia to the other in about a half hour," he says. But as he examined photos of the city in books, on postcards, and framed on walls inside restaurants, he realized that this classic and diminutive old Umbrian town had been photographed exhaustively. Finding fresh angles would be tough.

"I quickly developed a visual database of the city, based in part on century-old photographs. I realized that I couldn't necessarily reinvent the wheel but would have to improve on great shots already taken."

Justin Guariglia needed a high vantage point to shoot this street in Italy, so he enlisted the help of local firefighters.

Guariglia decided that a must-have overview was of the medieval Corso Vannucci, Perugia's main avenue. Here were cafés, boutiques, pastry shops, people seated at sidewalk tables, and a beautiful fountain at the far end. He studied the scene and realized he needed to get above street level to make his shot unique. But there were no rooftops, in fact, no buildings, where he needed them—in the center of the lane. He sought a ladder, to no avail. Then it hit him: Who has a ladder? The local fire department. The firefighters were happy to cooperate. They drove a fire truck into position exactly where Guariglia wanted it. He stood on the truck to find his shot. "I set my tripod up about ten and a half feet off the ground," he recalls. "Young ladies came by to flirt with the firemen, which kept them happy. They didn't mind when I asked them to move the truck closer in so I could get a tighter shot."

The vertical shot that resulted would fill the left-hand side of the opening spread in the magazine, giving readers an inviting view of the city's medieval architecture and active street scene. But he still needed a shot that said "sexy" and not just "historic," so Guariglia got back to work.

BE PATIENT

Along the same avenue, Guariglia found a lovely young couple seated at a table outside the classic pastry shop Pasticceria Sandri. They were attractive and seemingly in love. What came into play next was another critical skill of a professional photographer: patience.

"I wanted their permission to shoot, but I didn't want to approach them directly," he says. "They were having an intimate conversation. I didn't want to spoil the mood." Instead, Guariglia asked the proprietor of the shop to speak to the couple. He also ordered them more drinks and appetizers to keep them at the table longer. "I shot them for over an hour," Guariglia recalls, "changing angles and positions."

What took so much time was getting just the right composition. Shooting the pretty couple alone would've rendered a fashion shot. To be a travel shot, the picture

TIP

Street scenes are often most appealing when crowds of people are present, showing that the city or district is vital and stimulating, the way travelers expect a city to be. Deserted streets, on the other hand, can impart a sense of abandonment or decline. Plan your coverage of a city so that you're shooting where the people are.

needed the context of the 500-year-old city. "I wanted the patisserie in the background, with no other customers cluttering the frame," Guariglia says. "However, at one point a passerby did enter the frame, his arms swinging as he walked, representing movement on the street. I included him, adding one more layer." The picture of the couple filled the right-hand side of the opening spread, perfectly conveying the romance of Perugia.

BECOME INVISIBLE

Patience can have another benefit. The longer you stay in place, the more easily you're ignored by your subjects. One of the best pictures in the Perugia story was of a waiter in the historic patisserie, looking attentively out the window at women passing in the street and at his customers seated at sidewalk tables. "I set up my tripod only a couple feet from where he was standing and used a wide-angle lens," Guariglia says. "At first he paid attention to me, but eventually I was invisible. He was no longer interested. He focused on his work. That's what happens. When you arrive, you're the novelty, and you can't get good pictures. People are looking at the camera and are on guard. It takes at least 15 minutes for them to forget you. Then you can start getting the essence of the place."

> **TIP**
> Photogenic scenes can be hard to shoot. Warm up by shooting around the edges until you're calm enough to shoot the main subject.

CALM DOWN, SLOW DOWN

As odd as it sounds, sometimes the most difficult scenes to photograph are the ones that are most photogenic. "When I encounter something highly appealing," says Karnow, I tend to get overwhelmed and start to worry that I won't do it justice." Her remedy is to warm up first, like a musician playing scales, before getting down to serious shooting. "I'll start moving slowly around the edges until I calm down enough to shoot the main subject."

The example she gives isn't something grandiose like the Sistine Chapel or the Great Wall of China. Karnow can get equally excited—and overwrought—shooting a cupcake shop in Berkeley, California. "The cupcakes were so beautiful, and they [had] so many designs," she says of the assignment for *Traveler*'s City Life department. "The scene presented itself as a huge project involving a lot of arranging. So I started with a single

tray of cupcakes, which I took outside to shoot on the sidewalk. I shot for maybe 15 minutes, until I got used to the cupcakes and settled down. I noticed that one in particular had a beautiful swirl in the icing." Back inside, she used that cupcake, with a berry on top, as the focal point for an arrangement she made for the magazine. The result? Yummy.

Stay in place long enough, and subjects will ignore you.

LOOK FOR CONTRAST—AND TOURISTS

Many cities are a cultural melting pot, offering photographers opportunities to capture scenes of stark contrast. Will van Overbeek found delightful incongruity in London, including a shot of a Scottish bagpiper performing for Arab tourists. On that same assignment, he ventured into Madame Tussauds wax museum, fearing it was a crass tourist trap. "At first I felt like a chump," he says, "but then I noticed these great juxtapositions all around. People love to pose with the wax figures—the housewife standing with Hitler and Churchill, for instance. But I particularly liked a scene where a man in a turban was posing with Marilyn Monroe—aping her hand movements as she held down her billowing dress—while his new wife took a picture. It was great, campy fun." Go

Catherine Karnow found out when an evening service was scheduled so she could shoot this church while it was lit—and busy with people.

where the tourists go, van Overbeek says, and you'll find contrasts.

Of course, juxtaposition can apply to architecture shots as well. For a story on London, Karnow shot a futuristic office building known locally as the Gherkin. To make it distinctive, she chose an angle that put a diminutive, 13th-century church in the foreground. This created a contrast between old and new, huge and small. But she wanted even more interest in the picture. During scouting, she found out what day the church

would have an early-evening service. Her shot, taken at dusk, captures lights glowing from within and parishioners socializing outside. This multilayered shot covered a spread in the magazine.

DON'T OVERLOOK RESTAURANTS
Dining is a big part of the travel experience. Cuisine and dining traditions are emblematic of local culture. They're one of the most tangible ways that one destination is distinguishable from another. Shots of exotic,

exquisite, or funky eateries are standard fare in travel magazines, and professional photographers know they must bring home good restaurant shots to complete an assignment. But many amateurs overlook, or avoid, this potentially rewarding subject area. Perhaps they're put off by the shooting conditions: Restaurants, unfortunately, can be noisy, chaotic, and poorly lit.

Ease into the challenge by shooting pictures of your own experiences as a diner. A photo can make a memorable meal truly unforgettable—permanently. "Whenever I travel," says van Overbeek, "I always take a picture of my plate of food when it arrives at the table, even if it's just with a point-and-shoot camera with on-camera flash." While traveling in southern France, for example, van Overbeek stopped at a restaurant in the hillside village of Tourrettes, where he and his wife ordered the "pigeon surprise." "It sounded awful but turned out to be foie gras wrapped inside a pigeon breast and baked in a puffed pastry," he recalls. "It was the most amazing meal we ever had, and I captured it in a picture." Shoot pictures of your family eating, chatting with the waiter, holding their glasses up for a toast.

TIP

During the harsh light of midday, get your indoor restaurant shots. Catherine Karnow likes to arrive around 11 a.m., when the restaurant is neither crowded nor deserted.

Family shots will take you only so far, of course. To shoot like a pro, you'll have to step up to the challenge of shooting restaurants on your own, approaching strangers to be your subjects. As described earlier, Karnow scouts restaurants to find those with the best ambience and natural lighting. Then she returns, usually in late morning, to find her subjects. "I'm not working with models," she says. "I try not to rearrange reality. But I do want to capture what's most compelling about a particular restaurant."

To get the composition she needs, Karnow puts into motion her well-honed skills at photographing people (see Chapter 5, "Photograph People in Places"). At the Marxim, a cellar pizzeria in Budapest, for example, Karnow liked the look of a table full of young guys eating pizza, as well as a poster on the wall of Vladimir Lenin. But the two elements were apart. No matter. Karnow approached the young men, got their permission, and starting shooting, knowing she would discard these initial photos. "I just wanted to get the guys comfortable with the idea," she says. When their pizza was down to

one slice, she stepped up to offer them another pie, as well as another round of beers—all on her. "And, 'Oh,' I asked, 'would you mind moving to this table over here?' "

Now they were where she wanted them, below Lenin's picture, and it was time to bring out her tripod to get down to serious work. "I let them enjoy their food," she says, "but I did break in a couple times to ask one or another to move his chair a bit, to separate them. It's tricky when you're shooting a table full of people, some with their backs to you. You always want to be able to see at least a couple of faces clearly. You want a careful composition that doesn't look posed." Depending on the requirements of the particular publication, however, Karnow may decide not to disturb the reality of the situation at all.

Karnow took another memorable restaurant shot at the Bistrot Paul Bert in Paris. She arrived before 11 a.m.

Catherine Karnow asked this patron of a Paris bistro to resume reading the menu long enough for her to get her shot.

An arrangement of mussels, scallops, oysters, and salmon makes for an appealing dish at a restaurant in Hobart, Tasmania.

and waited. An older gentleman arrived. She liked his look, particularly when he started examining the menu on a chalkboard. "The menu was turned so I couldn't see it," she says. "He made his choice in a second and looked away. But it seemed like such a good shot. So I set my camera on the tripod and approached him, getting into my slightly eccentric mode, gushing to him how incredible he looked when he was gazing at the menu. My goal is to get the person worked up, through my enthusiasm, about how great the shot will be. 'It was such a beautiful moment,' I'll say. 'I would love to photograph what I just saw you doing!' It's all true, of course. The result is that they can't really say no. So we put the menu where I needed it, and I went back to the camera to compose the shot. Now he was looking at the menu. But the words were running into his face, so I

had to ask him to move a bit. Then I had to ask him to actually read the menu again and not just stare at it. And to remain motionless. When the composition was just right, I clicked about five frames." Within minutes, the lunch rush hit, but Karnow already had her shot, which filled a page in *Traveler*.

MAKE FOOD LOOK DELICIOUS

No restaurant shoot is complete without pictures of at least one of its signature dishes. Unfortunately, shooting food can be even more difficult than shooting restaurants. (The easiest food shots are often ones you get at outdoor markets or along sidewalks, where street vendors may be cooking up sizzling local delicacies with ample sunshine to light your composition.)

The travel photographer has to do triple duty, taking on the added work of food stylist and prop person, which are separate jobs when food is shot in studios by commercial photographers. "I can spend hours just shooting a salad," Karnow says. "The food has to look like you want to eat it right this minute." She increases her odds of success by shooting "safe" food—that is, dishes that won't melt or congeal, dishes that can hold their form for an hour or two. "You also want color," she says, "so salads and desserts [not ice cream] are good choices."

Ideally, Karnow will get her restaurant shots and food shots all in one visit. "I'll get to the restaurant at 11, as the staff is setting up for lunch. Then, a bit later, while I'm shooting people dining, capturing the life of the place, I'll be watching specific food dishes being served, narrowing what I want down to two or three dishes." When she's ready to shoot, Karnow will order the food and take the plates around the restaurant to find the best natural

A FEAST FOR THE EYES

When shooting food, what matters is that it *looks* good. Photographer Kris LeBoutillier asks the chef to make up a special photogenic dish, selecting colorful food items and avoiding whites and browns. "I want a dish with nice composition and form, even if that's not exactly how they normally serve it," he says. In most cases, he shoots the dish in soft, indirect natural light and with a shallow depth of field, focusing on one element and letting the rest of the composition go blurry. "That lends a romantic effect," he says.

light to shoot them in. "I don't know how to light food with flash, so I don't even try," she says. She uses window light, preferably side light or backlight, sometimes supplemented with a handheld, 22-inch-diameter reflector that's soft gold on one side and white on the other.

After she finds the right lighting, she'll set up the composition. "Sometimes I'll style the scene with a knife, fork, and napkin. Inevitably, you can't figure out where to put the damned fork. You want it to look natural and kind of whimsical but not perfect—sort of like the person is in the middle of eating it but they haven't actually touched the plate. A food shot still needs to have a lot of character. Then, when I'm ready to shoot, I'll order up another example of the dish to actually photograph, so it will look fresh."

Don't overlook beverages, either. Cocktails can be artsy and colorful, making for a dramatic foreground element. (Sometimes they're conveniently representative of place, such as the Cuba libre or Singapore sling.) Karnow likes to include a glass of white wine to signify elegance. When possible, she'll work with three wineglasses and a bucket of ice, keeping two glasses chilling while shooting the third. "You want condensation on the glass so it looks cold and inviting, and you want the bubbles that come up just after the wine is poured. So I quickly dump ice from the glass, quickly pour the wine, and then shoot for ten seconds or so before it's time to switch glasses."

GET DETAIL SHOTS

Another staple of professional travel photography is the detail, or "accent," shot. Typically, these are tight shots that run small in the magazine, adding color or flavor to a layout. Food or drink shots can serve this function, but professionals will also shoot jewelry, flowers, an ornate hotel key, a playful pub sign—anything that's "readable" without having to be published large. "The accent shot is something most travelers overlook," says photographer Kris LeBoutillier. "But that one little shot can tell the story of a place." While shooting an article on shopping in India for *Traveler,* LeBoutillier photographed little Ganesh statues, for example, and a pair of ornate slippers. His shot of the slippers pictured on the hood of an antique Austin roadster ran in *Traveler*

magazine and also became the lead photo of our Web-based Authentic Shopping Guide.

MAKE THE HOTEL ROOM INVITING

Like food, accommodations are a big part of the enjoyment of travel, and hotel pictures have a big presence in travel magazines. Hotels can be quirky, spectacular, avant-garde, or classic. Some hotels are destinations in themselves, wonderfully representative of local culture. But like restaurants and food, hotels often get short shrift from nonprofessional photographers, though they tend to be much easier to shoot.

Detail shots lend variety to magazine and Web page layouts. But amateurs often fail to shoot close-ups.

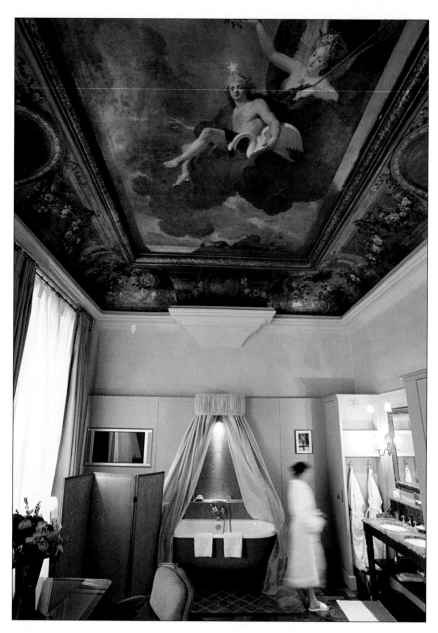

Catherine Karnow's shot of this distinctive Paris hotel room was carefully set up to look candid.

The goal is to make the accommodations look inviting. Start by shooting your own hotel room, and do it as soon as you arrive, before you mess it up. You might have to move a chair or two or otherwise style the scene for best effect. If at all possible, use available light. Karnow used to set up strobes and reflecting umbrellas to

shoot a hotel room. No more. "I choose a room to shoot according to how good the natural light is," she says. Today's low-noise digital cameras make shooting without a flash easier than ever.

Add a person to your composition to distinguish your photos from those on the hotel's own website. Professional photographers often travel alone, so the person is as likely as not a hotel employee enlisted into service as an impromptu model. For a feature story on inexpensive Paris hotels, Macduff Everton shot a chambermaid looking out a window at the Hotel du Champ de Mars. "When I arrived, she was cleaning the room, and I complimented her on what a great job she was doing," he says. "I apologized for interrupting her and asked if I could come back in five minutes to take her picture. I think she was flattered that I appreciated her work. Here was a chance to photograph someone who actually belonged in the room. Getting her wasn't a matter of luck so much as taking advantage of what I found." The shot exuded warmth, a picture of a woman proud of her work.

For her Paris story, Karnow was determined to photograph the Chambre à la Fresque at the Hôtel des Saints-Pères, built by one of Louis XIV's architects. To do justice to this truly distinctive room, famous for the tableau painted on its ceiling, Karnow had hoped to book it herself but could not. She had to settle for permission to shoot it one afternoon between checkout and check-in times, yet every detail had to be just right: Karnow begged a front desk clerk to come up and model in a bathrobe. She grabbed a bouquet of flowers from the lobby to set on the desk. She pulled the desk chair out at a certain angle. Her assistant constantly moved the window curtain so it would appear to be billowing, instead of hanging straight, in the reflection on the TV screen. And the model had to walk, at just the right speed, from bath to vanity, over and over. Karnow set up her tripod on the bed, stepped down off the unsteady surface to shoot with a cable release, and then stepped back up to recompose and back down again to shoot. The resulting picture, of course, looked casual and effortless.

TIP

It's easier to get access to shoot hotel scenes—of the lobby, lounge, guest rooms, or even the presidential suite—if you're a paying customer. But even if you're not, a hotel wanting favorable publicity may grant you access. Other hotels, however, where discretion is a priority, shoo away photographers, preferring to shield their guests from prying eyes.

Discover the Countryside

7 | *Discover the Countryside*

Previous pages:
Overlooking Assisi,
Italy, Aaron Huey
shot into the sun, using
a graduated neutral-
density filter to darken
the sky.

Travel is about escape. And for all the excitement and stimulation we find in cities, the urge to get away often leads us far from the bright lights and into the hinterlands. For stories set in the countryside, *Traveler*'s picture editors want more than dramatic landscape photography. They need photographers to get immersed in a place, to give readers a sense of what it would be like to travel there or live there.

FINDING SUBJECTS

So what do you shoot in the countryside? Do your pre-trip research (see Chapter 1, "Get Inspired") and make a shooting list just as you would when photograph-ing a city. But also realize that serendipity will play a large role. When shooting rural areas outside Nashville for *Traveler,* Will van Overbeek called on friends for sugges-tions and also looked up settings in a popu-lar historical novel, *The Widow of the South,* that writer Pat Kelly had read just before the assignment. That led them to Carnton Plantation near Franklin, Tennessee, where van Over-beek found plenty to shoot. "But as we were leaving the plantation, we took a wrong turn and ended up at a cemetery. I got beautiful night pictures there, unexpect-edly, of the Confederate tombstones, using only our car headlights for illumination."

Part of their route of discovery relied on happen-stance, but van Overbeek says he and the writer also used a portable GPS unit that he had bought second-hand. "It came preprogrammed with local attractions," van Overbeek says. In effect, the gizmo did some of their research for them.

STOP, LOOK, SEE

Shooting in rural areas, you're most likely to be traveling by car rather than on foot, as in a city, so you might acci-dentally zoom past good pictures. Drive slowly. Subjects here can be more subtle, less in-your-face, than those

> **TIP**
> Use a shooting list in the country but realize that serendipity will play a large role in finding shots.

The Mint Bar in Opheim, Montana, has a classic rural decor that was perfect for Aaron Huey's assignment, "The Last Real America."

in cities. For the article "The Mystery of Exit 69," writer Barbara Lazear Ascher followed a back road into rural Connecticut. She stopped in small-town coffee shops, antiques stores, bed-and-breakfast inns, homey restaurants, and small-town taverns. Photographer David McLain followed her route later with the manuscript in hand, knowing he had to do visually what she did in her writing—evoke the joys of a slow-paced lifestyle close to the land, where simple pleasures are the rule. He didn't necessarily shoot the exact places that she wrote about, however, because many weren't photogenic. His job was to capture the spirit of the article.

"It was more emotional than intellectual," he says of his exploration of the route. "I wandered down all these roads looking for the allure of old country highways." Likewise, when *Traveler* photographer Aaron Huey shot

a story on rural northeastern Montana, "The Last Real America," he found himself only loosely following the manuscript. The article recounted writer Carl Hoffman's exploration of Big Sky country, "a classic American landscape of huge, open, rolling space and sprawling ranches." The writer had come here to see for the first time a natural gas well he had inherited, meeting ranchers and gas field workers.

Huey set out to capture life in small towns and on big ranches. Like McLain, he was exploring on his own, creating a vision parallel to the writer's. "The photos were not a literal interpretation of the story," Huey says. "I wasn't worrying about getting pictures of everyone featured in the text." One of his shots was a still life in a small-town bar, where a typical dinner is a hamburger served on a plastic-foam plate. The composition took in beer signs, a jukebox, a stuffed deer head hanging on the wall. Published on the facing page in the magazine was a picture of a dog looking out the window of a moving car, watching the prairie roll by.

TIP

Chat up the locals in small-town diners and cafés, and tell them you're looking for a farm to photograph. An invitation may result more readily than you'd expect.

YOUR CAMERA IS YOUR PASSPORT

In cities or heavily touristed areas, some people will find your camera off-putting. But in rural areas, it can open doors. People who normally live in obscurity may welcome the attention of a stranger taking pictures. Another shot McLain got in Connecticut was of a man sitting in his old truck, talking to his pet calf standing beside it. "In this case, my camera acted like a passport into that guy's life," McLain says. "I befriended him while we were both stopped on the road to let some cows pass. He invited me to go along as he rounded up more of the herd. So I ended up spending a couple hours with him. You have to roll with the situation," McLain continues. "Be flexible. Go where it leads. Embrace the unknown. If I had been determined just to shoot a landscape, I would've never gotten into that truck—or gotten that shot."

EXAGGERATE SPACE
WITH A WIDE-ANGLE LENS

To do justice to Big Sky country, Huey knew he needed shots of wide-open territory. "Sometimes I like to

exaggerate space," he says, referring to his use of a 20mm, 24mm, or 28mm wide-angle lens. Driving down a country road, he noticed a lonely barn sitting in a sea of grass. He stopped to work the scene from different angles. "When I sat down in the grass, the shot came together." The result was like an Andrew Wyeth painting, with the expanse of grass looming large in the foreground and overwhelming the picture. Another shot exaggerates space even more, showing a lone rancher on horseback in the middle of a wide prairie, an endless blue sky overhead. Huey, who was riding in front of the rancher, composed this shot without even looking through the camera.

"I shot it over my shoulder," he says, "pointing it back behind me at the rancher," he says. "Shooting with the camera held away from my eye loosens up the image. It

David McLain used a 300mm telephoto lens to compress the space between the road and the barn.

counteracts the tendency to overcompose." The picture had a slanting horizon line—violating a rule of composition—but *Traveler* ran it nonetheless as the opening spread of the article.

GO WIDE (SHOOTING THE PANORAMA)

A wide-angle lens is not always wide enough. That's when some travel photographers switch to the panoramic format. Panoramas are loosely defined as images that cover a field of view at least as wide as that visible to the unaided human eye, roughly 150 degrees. Specialized panoramic cameras—or panoramic digital techniques—can achieve such breadth with far less distortion than what you get with an extreme wide-angle lens. "There are situations when a regular camera doesn't give you enough information," says *Traveler* photographer Macduff Everton, whose panoramic landscapes are showcased in the book *The Western Horizon*.

Making the common unique. One big advantage for Everton is that his panoramic film camera, a rotating-slit Noblex, can help him achieve an uncommon composition of a common landmark. "It's my job to offer a fresh view of something you've already seen a million pictures of," Everton says. Shooting the Golden Gate Bridge, for example, Everton emphasized Fort Point, a fortress situated beneath the bridge and built decades earlier. His panorama captured the entire fort and most of the bridge.

Matching the format to the landscape. Photographer Jim Richardson favors his panoramic camera, a Hasselblad XPan, for shooting western landscapes. He used it on an assignment tracing the westward journey of settlers along the Oregon and California trails. "I wanted to see the landscape exactly as they saw it, in the same seasons," Richardson says. His picture of storm clouds sweeping a central Wyoming prairie a few miles from

This panorama shot in Chiapas, Mexico, combines foreground, mid-ground (the figure), and background (the waterfall) elements.

TIP

A tripod, particularly one with a built-in spirit level, will help you shoot digital images that are straight, making them easier to stitch into a panorama later.

Independence Rock made it into *Traveler*. "Few areas have such a wide, pristine landscape," he says, "with no people, telephone poles, or roads"—a landscape begging for panoramic treatment.

Shooting indoors. Everton has grown so fond of his panoramic camera that he now uses it indoors as well as for landscapes. "I took panoramic shots of a bedroom in Wordsworth's Dove Cottage," he says of a shoot in Grasmere, England, "because there was so much in the room to capture." One image shows almost everything visible along three walls of the room—washbasin, fireplace, bed, wall hangings, open door—all in one composition.

Digital panoramic photography. Despite the enduring popularity of panoramic film cameras among professionals and serious amateurs, it is digital cameras that have caused a renaissance in panoramic photography by making it accessible to anyone—no special gear required. Many digital point-and-shoots come with a "stitch assist" feature, allowing you to shoot a series of images, still seeing half of the previous image while shooting the next one, helping you to line them up on the display screen. To create your panoramic image, you transfer all the constituent photos into a folder on your computer. Then navigate to that folder from within the panorama software that

came with the camera and activate the stitching function. The computer combines the images into one, and then, typically, you crop the image to your liking and can apply corrections. Other, third-party software programs tend to be more powerful than what comes with your camera, some even working with stacked images instead of just pictures taken side by side.

While digital panoramic photography has some obvious benefits over film, it also has some challenges—particularly the business of getting multiple images to line up correctly.

Watch out for moving people. Hungarian photographer Daniel Seer used his digital camera to create a striking panoramic view of the rooftop of architect Antoni Gaudí's Casa Milà apartment building in Barcelona, a surrealistic structure incorporating bizarre ice-cream swirls and helmeted knights. Seer set up his tripod and took seven shots of the rooftop, with the camera oriented vertically to give maximum depth. That allowed him to capture, in the foreground, the vertiginous roofline plunging into an open courtyard. Later, he stitched the images together on his computer, side by side, using PTGui software, to create a horizontal panorama.

A challenge Seer faced in working with multiple images was having to shoot the pictures when no people were on the rooftop. "If you have crowds of people

Macduff Everton shot this from a glider using a panoramic film camera. The shot couldn't have been done by stitching multiple digital images together.

Catherine Karnow used tree branches to block direct sunlight as she shot this sidelit cyclist. The branches became a strong foreground element.

walking around, the same person might appear in the composition twice, or someone might stand in the place where two pictures will be stitched together," he says. To overcome this, Seer dashed back to the rooftop at the end of his tour, when everyone else had left.

Find the edges of the composition first. "Many people who pick up a panoramic camera don't pay attention to the edges of the scene," says Everton. "No matter what, they'll put the subject in the center without thinking about the entire composition." Instead, find elements at either side to frame the image, and make sure there's no clutter in between.

Follow these additional tips. Shoot your component pictures with a medium, not a wide, focal length, to reduce distortion. Set your camera on manual exposure and manual focus so that settings can be uniform for all the images you plan to combine. Shoot with a small aperture for a deep depth of field, keeping everything in focus. Overlap your images by a third or more to make stitching them together by eye on a computer screen easier. The redundant areas will merge in the finished picture.

Shoot wider than reality. Italian photographer Stefano Signorini shoots panoramas digitally in order to create an extra-wide field of view. One August, he shot the northern Italian village of Cassone at dusk, with street-lamps and waning daylight penetrating layers of gloom descending from the slopes of Monte Baldo in the background. To intensify the otherworldliness of the scene, he shot a sequence of 15 vertical photographs that he combined horizontally with PhotoVista software. The resulting composition spanned 270 degrees, taking in a far wider field of view than possible with the human eye. "This kind of panorama makes visible something our eyes cannot see in a single gaze," Signorini says. "It creates a new reality."

Still, the magic of digital panoramas is not for everyone. Everton has tried shooting panoramas digitally but still prefers his specialized film camera. He can hand-hold it, and there's no fussing with multiple images later. "I hate carrying a tripod," he says. "As soon as you get a tripod out, it changes how you shoot." One remarkable hand-held panoramic of his that ran in *Traveler* was an aerial view of the Shasta Valley in northern California. He shot it from within the cramped cockpit of a glider plane soaring through the sky—with no room for tripods.

COMPRESS SPACE WITH A LONG LENS

Use a long lens to bring together elements that might otherwise be too far apart. In his rural Connecticut assignment, David McLain used a 300mm telephoto to pull a distant barn up close to a hump in the hilly lane in the foreground, making it appear almost as though the barn were sitting in the road. When shooting in Siberia, capturing himself and a writer hitchhiking along a narrow highway, Aaron Huey set up a tripod and shutter timer to photograph the scene with a 400mm lens.

FIND PANORAMIC SOFTWARE ON THE WEB

Several software programs available online are better than the panoramic-stitching programs that come with some digital cameras. Hugin *(hugin.sourceforge.net)* is not the easiest to use, but it's free. Autopano *(www.autopano.net)* has a "ghost remover" for deleting people or objects that have moved from one frame to the next. PTGui *(www.ptgui.com)* can stitch 360-degree cylindrical panoramas.

Palani Mohan's vertical shot of a devotee standing before a Buddha made the cover of Traveler.

The long focal length brought closer a distant mountain ridge, "crushing the space," as Huey puts it, between the hitchhikers and the mountains. It also served to emphasize the curvature of the serpentine roadway, an ideal subject for the long lens.

LANDSCAPES NEED A STRONG SUBJECT

Compositionally, says *Traveler* photographer Kris LeBoutillier, landscapes need a strong subject "besides the pretty mountains in the background. It can be a rock, a tree—anything distinctive." Even better, he points out, is a person doing something that relates to the place, like "a farmhand working in a pasture. That starts to tell the story of the landscape." For a *Traveler* article on Vietnam, titled "Indochine: An Affair of the Heart," LeBoutillier shot the Perfume River just after sunset, as a lone boatman crossed a broad expanse of quiet water, with purplish mountains in the background and the branches of a conifer jutting into the frame in the foreground. The boatman, though small in the picture, was critical, giving readers a sense not just of topography but also of culture.

CATCH THE LIGHT

How well you work with natural light—and shadow—will largely determine your success with landscape photography. In most situations, as LeBoutillier points out, the best possible light is angular, coming near sunrise and sunset, on clear days, when colors are richest.

Work with dapples. If you find yourself shooting in deep woods, hope for an overcast day to avoid the harsh dappling effect of direct sunlight shining through leaves. But sometimes dappled light is unavoidable. For a *Traveler* story retracing the route of the Lewis and Clark expedition, Everton photographed a line of Native American horseback riders, wearing traditional Nez Perce garb, coming down a wooded trail under harsh dappled light. "In a situation like that, I'll overexpose a bit, so the shadows aren't black," Everton says, "and shoot at a point when the faces aren't in shadows." The picture was successful enough to merit a spread in the magazine.

Shoot when the ocean is bluest. Everton also identifies other exceptions to the rule of shooting landscapes at

SHOOTING WITH VEHICLES

Vehicles can achieve different motion effects depending on how they're used. *Shoot still subjects from a moving vehicle.* Will van Overbeek shot country scenes in rural Georgia from the passenger seat of a moving car. "Roll down the window," he says, "and use your body as a shock absorber, not touching your hands to any part of the car. Focus on infinity and let the foreground go blurry from the motion."

Shoot moving vehicles while you're stationary. For the same article, van Overbeek stood across the road from a small building covered in kudzu vines. Holding his camera steady, he clicked his shutter as a motorcycle zoomed past, appearing in the composition as a blur, while the kudzu was tack sharp.

In Italy, Aaron Huey did a stationary shot with the opposite technique: Standing in place, he panned his camera to follow a cyclist pedaling by, getting part of the rider in focus against an utterly blurry background. "I shot it at one-fifteenth second," he says. "I let the background blur out because the scenery there wasn't interesting at all."

Shoot moving vehicles while you're in motion. Catherine Karnow likes to shoot moving vehicles from another vehicle moving at the same speed. "I ride side by side," she says. Keeping up with her moving subject, she can try different shutter speeds to get varying effects of motion. Karnow got a wonderfully evocative shot of a gardener carrying colorful vegetables in a box tied to the back of his Vespa with bungee cords (above). The scooter was zooming along the road while she shot from the backseat of an open convertible.

the magic hours of dawn and dusk. "Noon can be a great time, too, if the light is right. If you're in the tropics, for example, noon is when you get those incredible transparent blue Caribbean waters. Shooting in early morning or late afternoon, the water is going to be much more opaque. If you're at the Grand Canyon under a cloudless blue sky, your light is going to be harsh, and possibly the only time you can shoot would be early morning or late afternoon. But if you're there at midday with white, puffy clouds or storm clouds rolling in, the light will be much more interesting."

Don't obsess over sunsets. Amateur photographers tend to shoot sunrises and sunsets, but rarely do such photographs appear in *Traveler,* nor do *Traveler* photographers spend much time shooting them. "I don't purposely shoot the moment of the sun hitting the horizon," says Huey. "It's just overdone. But the moments before the sun comes up or the moments just after it goes down— that's when I'm shooting. The light is really even then. The color is interesting. Objects are illuminated without the harshness of direct light."

Shoot into the sun. Sometimes Huey will shoot into the late afternoon sun, however. While shooting "Shifting Gears," an article about a mother-and-son bike trip in Italy, he got a shot of the valley of Assisi while the sun was still above the horizon, breaking through clouds. He exposed for the foreground, using a graduated neutral-density filter to keep the sky from burning out. In the mid-ground was the often photographed Basilica of St. Francis of Assisi, the true subject of his composition. "Having that church kept this from being a generic countryside shot," he says. The picture showed the basilica in the context of its surrounding landscape, with olive trees and a twisty road, making the shot more evocative of the region than a tight shot of the building alone would have been.

Use silhouettes. When Catherine Karnow was shooting "The Other Napa" for *Traveler,* she also shot into a late afternoon sun, using backlight on a partially wooded hillside where a mountain biker was riding on a trail. She asked the cyclist to ride back and

TIP

A still body of water may let you shoot a reflection, but that alone won't make a good picture. "Don't lose sight of what the entire composition should look like," says Macduff Everton. Reflections are darker than the objects being reflected. Use a graduated neutral-density filter to balance the exposure above and below the reflection line, reducing the bright area by one or two stops.

forth in a particular clearing. She stood behind a large hanging branch of a California oak and used it in her composition. "I needed something to block the direct sunlight," she says. This produced a dramatic silhouette of the tree branch while backlight brightened the biker's orange jersey. The composition went beyond pretty. Framed with a tree emblematic of the region, it gave a strong sense of place.

Shoot with the sun. Everton says he likes to shoot in the direction opposite the sunset—that is, *with* the sunlight rather than against it. "In the Grand Canyon, while everyone else is shooting the sun going down, I tend to turn around and shoot where the light is falling. That's often the best picture."

WAIT FOR IT

If half the battle in making a good landscape shot is finding the right vantage point, the other half is waiting for all the right elements of the composition to come together. LeBoutillier's shot of the Perfume River, referenced above, needed the boatman—in just the right spot—as he crossed the water. Without that element, the picture may never have been published. When he finds a good vantage point, LeBoutillier says, he will park himself and wait for the composition to happen. Another example is his shot of the mausoleum of Khai Dinh, an imperial tomb, in Hue, Vietnam. LeBoutillier composed his shot, catching afternoon shadows cast by statues of scholarly mandarins, but he didn't click the shutter until a young woman strode through the scene, holding an umbrella to shade her from the sun. She gave scale to the statues and a dynamic human element to the composition.

Likewise, Huey exercised extreme patience to get a shot of a flood-damaged Sufi shrine in Pakistan that filled a spread in *National Geographic* magazine. "I walked around the place all day long," Huey recalls, "just waiting for the right character to arrive, for the right scene to unfold." Finally a robed man arrived and knelt at the grave of a loved one in the foreground—and Huey got his shot. To make a good landscape, Huey says, "You've got to have all the elements together—the place, the light, and people. I always wait for people."

> **TIP**
> When everyone else is shooting the sun going down, turn around and shoot the scene where the waning sunlight is falling, instead. That's where the best light is.

SHOOT VERTICALS, TOO

Landscapes are wide and horizontal, but don't forget to shoot vertical compositions of them. Professional photographers shooting for magazines know that many, if not most, of the pictures that get published will be verticals, filling one page or less than a page. Horizontal images covering two full pages—the coveted "double truck"—are the exception rather than the rule. The most sought after position in the magazine, of course, is a vertical—the cover. For that spot, not just any vertical will

Jim Richardson rented a plane and pilot from Land's End Airport in Cornwall, England, to get this shot of fields and stone fences.

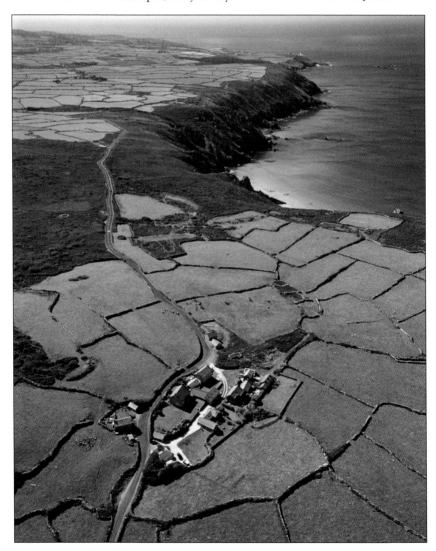

After composing his shot, Kris LeBoutillier waited at this mausoleum in Hue, Vietnam, until a person walked through, providing the missing element.

do. The shot has to be visually outstanding, but it must also accommodate the name (or "flag") of the magazine across the top, without overlapping the subject. There must also be uncluttered space for cover lines (words touting particular articles) along both sides of the composition, and the background in those areas must be neutral enough for text to be legible. "Overall, the composition for a good cover image needs to be simple, with an uncomplicated background," says photographer Palani Mohan, whose vertical shot of a devotee standing before a Buddha in Sri Lanka graced the cover of *Traveler*.

GETTING HIGH

Just as they do with city stories, *Traveler* editors want pictures of the countryside that answer this basic question: "What does the area look like?" That means, once again, the photographer needs to get an overview shot, a big picture.

While shooting "Insider's Provence," Karnow managed to get an overview shot of this region of France—as well as a high-angle shot of an inviting hotel swimming pool—all in one composition. But it didn't fall into her lap. The pool had a nice view of the countryside but

was otherwise ordinary. Karnow found a vantage point behind a hedge, putting foliage into the foreground. To get the high angle she needed, she set a chair atop a table and her tripod atop the chair. "I had to set this up just right, or the pool would've turned out looking like any other pool anywhere," she says. The other problem? It was early morning, and there were no swimmers around. Solution? Jump in herself. Karnow enlisted a hotel employee to click the cable release repeatedly as she swam across the pool. The picture that resulted filled a page in the magazine.

Aircraft. When there are no towers or natural vantage points for the high shot, sometimes *Traveler* photographers will hire an aircraft to take them aloft. Options include planes, helicopters, and even hot-air balloons. When working on a *Traveler* article titled "Lost in Cornwall," Jim Richardson went up in a small plane to get his opening shot—an aerial view of a patchwork of cultivated fields delineated by old stone fences. "Geography and geology spring to life when you're in the air," Richardson says. "I could've spent days looking for the perfect angle for shooting those stone fences. But I saw this scene five minutes after taking off from the Land's End airport, laid out like a quilt in front of me."

Richardson prefers a high-wing (over the cockpit) Cessna-type plane with a window that opens. (Some photographers have the airplane door removed.) To find a plane, he'll look in the phone directory under "flight instruction" and then negotiate a rate. "Helicopters are too expensive," he says. "Small planes can be had for about $150 an hour." He goes up a few minutes before dawn or an hour before sunset for good light. "The tendency is to shoot from too high up," he says. "Everything looks great from up there, but then you get down and realize the subject is too small in your pictures." He got the Cornwall shot from just 1,000 feet up. "Stay low and shoot with a wide-angle lens," he says. "Shoot with a fast shutter speed, and don't touch the plane with your arms or elbows [to avoid vibration]. Pay as much attention to composition and scale as you would on the ground. Positioning the aircraft is complicated. When you're low, everything will go by fast, so you might have to make multiple passes. It's not easy, but it's fun."

Chapter 8

Add Adventure
and Nature

8 | *Add Adventure and Nature*

Previous pages:
Michael Melford
likes to shoot
running wildlife
with a slow shutter
speed to achieve
motion effects.

Journeys outdoors can be the most exciting kind of travel, leading to dramatic pictures of nature and wildlife. But outdoor photography has its own special challenges.

IT'S STILL ABOUT PEOPLE

Everyone likes to shoot pretty pictures of mountains, but the truth is, magazines like *Traveler* rarely run them. Good travel photography is about the experience of a place—not just the landscape but people engaged with the landscape. When *Traveler* sends photographers halfway around the world, we don't want them to come back with pretty pictures. We want their pictures to evoke a particular journey.

Photographer Aaron Huey knew this as he was shooting "The High Road to Machu Picchu" for *Traveler,* a story about hiking the lofty Camino Salcantay to the ancient ruins. "The mountains were spectacular," he says, "but I didn't want a generic mountain shot." Instead, Huey hustled to get good shots of hikers on visually interesting parts of the trail. That meant trotting ahead of the group, literally, to scout out locations. One of the two opening pictures in the story is of hikers negotiating a steep, winding trail against a mountain backdrop. Huey scrambled up the mountain slope, climbing above the trail, to get the picture. "I found a place where the route had a nice shape and where I could get a whole line of people at once," he says. Then he waited for the group to arrive in the sweet spot below him.

The hardest part of the assignment was shooting Machu Picchu itself, because the famous landmark has become such a cliché. Making matters worse, thousands of people were crawling over the ruins when the group he was covering arrived. To meet the challenge, he enlisted a few of the hikers in the group to circle the periphery of the ruins with him, looking for good, uncluttered compositions. He finally got his shot in the last hour of sunlight, after the tour buses had left. The picture, which ran across a spread in *Traveler,* showed the hikers mounting

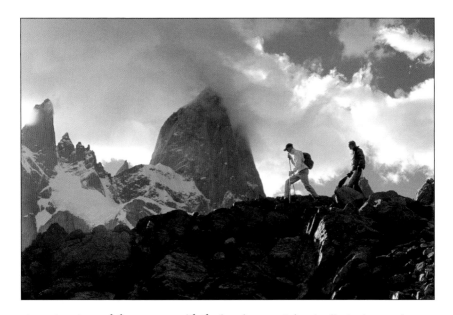

stone steps toward the camera, with the iconic mountain peak Huayna Picchu in the background. That element made Machu Picchu immediately identifiable, yet the composition, emphasizing the approaching hikers, was completely fresh.

Traveler sent Pete McBride to southern Chile and Argentina to photograph "Knocking on Heaven's Door," an article about the wilds of Patagonia. The opening-spread picture is of Mount Fitz Roy in the Patagonian Andes. You can find thousands of pictures of this mountain on the Internet. What sets McBride's composition apart is the inclusion of two hikers striding along a ridge, shot from a low angle, silhouetted against a partly cloudy sky with the peak off to the side. One of the hikers wields ski poles to keep his balance. Shots like that go beyond pretty, allowing readers to imagine themselves in the subjects' shoes, experiencing the climb on their own.

Get the face. Photographer Vince Heptig, who works primarily for the Boy Scouts of America's publications *Boys' Life* and *Scouting,* has shot literally dozens of outdoor adventure stories over the past 30 years: climbing, mountain biking, whitewater rafting, wilderness canoeing, you name it. (During my years as editor of *Boys' Life,* I was often with him as a writer, notebook and pen in hand.) You could sum up Heptig's strongest advice for shooting people in the outdoors this way: "Get the

Capturing people engaged with the landscape is far more interesting than generic pretty mountain scenery.

face." He knows that his editors, like those at *Traveler,* want human interest in their outdoor shots.

Getting the face may sound obvious, but in fact, most people shooting hikers, horseback riders, cyclists—any groups in motion—tend to make the same mistake: They shoot the backs of people because they themselves are traveling in the line. The fix is, again, to hustle up ahead and lie in wait, getting face shots as people approach. This means, of course, that the photographer, constantly running ahead, exerts more energy than anyone else in the group.

Go back and come back. After he has rushed ahead, found a good vantage point, and taken his shot, Heptig will frequently ask the group he's photographing to go back and approach again, so he can have another chance. It's just another way of working a scene. When shooting Scouts hiking in southern Arizona among dramatic rock spires known as hoodoos, for example, he had the group round a certain corner in the trail several times. "You often need a second chance," he says. "Someone may be looking straight at the camera or making a bad face. That's when you need to shoot it again." He adds that "you've got to give some instructions. You're shooting a play in a vast theater, and you are the director."

Get people looking at the view, not at you. Another composition that rarely makes it into publication is that of your traveling companions standing before a gorgeous overlook gazing at the camera. Better to shoot people engaged in the scene; if nothing else, have them look at the view, not at you. "The basic approach is that you want to shoot pictures of beautiful places and of people having a blast there," Heptig says.

SHOOTING THE RIVER TRIP

When shooting river trips, get some shots from afar, as the boat approaches, to capture looks of excitement on boaters' faces.

One of the more difficult outdoor shooting assignments is the river trip. White water, in particular, poses a constant danger of flipping your boat and sending your gear (and you) to the bottom of a stream. Yet whitewater river running makes for more dynamic shots than most other forms of outdoor adventure.

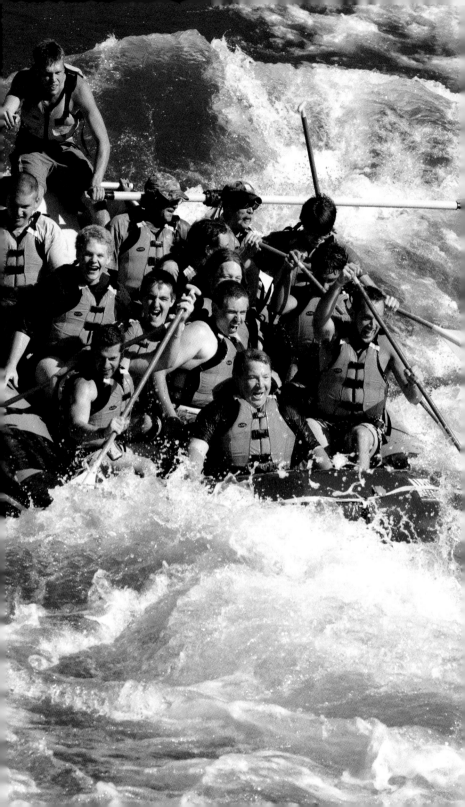

Avoid having to buy costly strobes by shooting underwater shots in shallow water under bright sun.

Shoot from the riverbank. Amateur photographers tend to shoot the action only from within the boat itself. Professionals know that you need a pulled-back composition as well, showing the boat from the outside. That means getting the boats to stop upstream of a rapid to let you hop out and hurry downstream to find a good vantage point. Then shoot the boats as they approach in the big water. Heptig shoots this scene with a 70-200mm zoom lens, often with a 1.4x extender in place for a longer focal length. "The shot has got to be tight enough to show the boaters' faces as they're screaming," he says.

Shoot on the boat. When shooting from within the boat, Heptig will compose from different angles. From the stern, he'll shoot forward at the rafters' backs as they head downstream. But often a better composition is to hunch down in the bow of the raft and shoot upstream, getting the paddlers' faces as they confront what's coming. For this, a wide-angle lens or fish-eye lens gives the best results. "A good shot is one of everybody getting soaked in a crashing wave," he says.

McBride agrees that shooting in both directions—from the bow and from the stern—is necessary. "I'll lie down on my back in the very front of the boat and then get in the back to shoot the paddlers as we're entering the maw," he says. Set the camera on shutter priority and try both fast and slow shutters.

While shooting "Ch . . . Ch . . . Chillin' on the Tatsh-enshini," a story about running a wild river in British Columbia, photographer David McLain got a classic from-the-bow rafting shot, using a fast shutter to freeze individual droplets of water splashing over the boaters.

Keep your camera dry. Dry containers for stowing camera gear have evolved considerably since the days of ammunition cans fitted with Styrofoam. Many photographers haul their cameras in cases manufactured by Pelican, which have O-rings and tongue-and-groove fittings to keep water out. "You carabiner the case to the raft," Heptig says.

While shooting, keep your camera dry with an underwater housing such as those made by Ewa-Marine. McBride calls them "glorified Ziploc bags." They completely enclose the camera and flash unit and have a port for the lens. Photographer Heptig uses actual Ziploc bags—the heavy-duty kind—on whitewater trips, cutting a small slit in the bag to push the lens through. Heptig rarely takes his newest gear out on water, though, because he is still smarting over the destruction of a $1,500 lens during a multiweek canoe trip in northern Canada. "I have to balance the quality of the images with the cost of replacing the camera," he says. "I'm not going to take a $6,000 body out on the river."

GO UNDER

As mentioned above, you can keep your camera dry, even underwater, with special housings that are available for both SLRs and point-and-shoots. The cheaper type of housings are soft bags. More durable are hard-plastic housings made to fit particular camera models. The hard housings are more watertight at deeper depths, but keep in mind that the deeper you go, the bluer the natural light, meaning you'll need expensive strobes to keep colorful fish colorful.

TAKE CARE OF YOURSELF

Outdoor adventure imposes great demands on your body. "You've got to take care of yourself," says Pete McBride. "If you're exhausted or dehydrated, you won't get good pictures." With your camera gear, your pack will probably be among the heaviest in the group. That means you have to be in at least as good physical condition as the people you're traveling with.

Avoid this problem by shooting in shallow water, particularly above reflective sandy bottoms and under bright sun, says Bob Krist. "I don't carry an underwater flash," Krist says. And due to sinus problems, he no longer scuba dives. He gets his wet shots by snorkeling. When shooting a story on the South Pacific island of Bora-Bora for *Traveler* called "Adventures in Paradise," Krist shot a photo in shallow water of a bright orange tropical fish swimming near coral. He got the shot with a wide-angle lens, shooting through a housing with a domed port that accommodated the wide field of view. The fish was only inches from his camera. Krist says his most popular water compositions, judging by his stock sales, are his "half under, half over" pictures shot right at the water's surface—no strobes or diving gear required.

SHOOTING IN COLD WEATHER

Beware of condensation. Use desiccant bags (packs of silicon gel) in your camera case to absorb moisture, says McLain. He spent weeks photographing in frigid temperatures in Greenland and cautions against subjecting your camera to fast temperature changes, which cause condensation to form. When bringing your camera in from the cold, put it in a Ziploc bag and squeeze out the air before sealing, he says. Then let the camera warm up slowly in its case or camera bag. Pack extra batteries, as well, because they die more quickly in cold weather.

Shooting on snow. Light reflecting off snow causes your camera's meter to stop down, leading to underexposed pictures and images in which the snow appears gray instead of white. McBride counters this by taking a meter reading off the back of his hand. Another option is to set your automatic exposure compensation dial to open up by one or two stops. Shadows in snow scenes may appear blue due to higher ultraviolet light levels, so warm up the lighting by using a UV filter, adjusting your white balance, or both. Polarizing filters can also enhance snow scenes. If snow is falling, experiment with fast shutter speeds—to capture individual snowflakes—or slow ones, for a hazy, dreamy effect.

SHOOTING WILDLIFE

Traveler contributing editor Michael Melford says photographing wildlife—whether a squirrel in the backyard

SHOOTING IN THE RAIN

Rain can damage or ruin your camera, but it can also make for great pictures. Carry a good umbrella, a box of plastic bags, perhaps a small tarp (some are specially made for photography), and a towel with which to dab your equipment. "Rain brings dark clouds, rainbows, moodiness, broken light, dappled light, and contrast," says Pete McBride, who took advantage of such conditions (above) while shooting "Dublin Without a Pint," a story about an outdoorsman exploring a big city via a marathon race. "The best part of a rain is before or after it," he says, when clouds are forming or breaking up and lighting can be eerie or dramatic. Perhaps the best shot in "The Beat in Cuba," another story McBride shot for *Traveler,* was an atmospheric composition of a cyclist pedaling along in the rain while holding an umbrella.

Take advantage of overcast conditions. Although it is less dramatic than late or early sunlight, cloudy weather offers soft, even lighting, free of harsh shadows, which can be ideal for portraits, rendering even skin tones, and can enhance saturation. It's also a good time to shoot waterfalls and other scenes of flowing water in the outdoors. The muted light allows you to set a slow shutter speed to achieve a flowing water effect without blowing out the highlights.

or a cheetah in Africa—is always thrilling. Keep in mind, he says, that wild animals are wild. If you rush at them, they're likely to bolt. Approach very slowly, let them approach you, or learn enough about them before your trip to anticipate their behavior so that you can position yourself to get a picture. "Animals are more predictable than humans," Melford says. For example, "When you see a bald eagle on a branch, just hang out and train your lens on it. When the bird starts to lean forward, you know it's about to take off." When it does, get your shot. Likewise, if you know how long a humpback whale stays underwater, you'll know when it will resurface and can be ready.

Michael Melford shot this chameleon using a wide aperture and focusing on its eye, letting the body go blurry.

Photograph it where it lives. A favorite composition of Melford's is an environmental shot showing the animal surrounded by its habitat—rather than the usual tight shot taken with a long lens. In the *Traveler* article "Into

Africa," Melford's picture of a bull elephant in the Ngorongoro Crater, shot with a 100-400mm zoom lens, is mostly filled with the forested crater wall and a foreground of brown grasses. The elephant itself is but a small element in the picture, yet there's no mistaking that it's the subject of the photo. Similarly, a composition of three zebras shows only the upper half of their bodies as they walk through the grass, with landscape elements taking up most of the frame. These are wildlife shots that impart a sense of place, an ideal approach for a travel magazine.

Melford's other favorite technique is to shoot wildlife with a slow shutter—he starts at 1/15—to impart a sense of movement. In the Africa piece, he shot a group of pink flamingos in Lake Magadi using a tripod. When one of the birds flapped its wings, he clicked the shutter, capturing a blur of motion. In another shot, he captured running giraffes, panning with them as they moved, their bodies sharp in the picture against a blurred background.

Go step by step. In "Fighting Fire with Fur," an article about threats to Madagascar's wildlife, Melford got wonderful close-ups of frogs, chameleons, and lemurs. In this case, his strategy was to photograph the animals from where he was standing when he first saw them, and then to step in slowly. "You want to get the shot you have," he says, "rather than rushing in, scaring away the animal, and getting nothing at all." So it's a matter of shooting, stepping in, and shooting again.

Use a shallow depth of field. In general, a shallow depth of field works best for close-up shots of wildlife, Melford says, whether shooting with a macro lens or a telephoto. "Shoot wide open and focus on the eyes," Melford says. That blurs out background distractions and, in the case of the chameleon he shot, the rear half of its body. The animal would not have "read" well, due to its body position, if all of it had been in focus.

Get a catch light in the eye. Most animal close-ups are better if there's a catch light in the eye, Melford says. You can get this late or early in the day if the animal is facing the sun, or you can achieve it using a flash unit set on a dim, fill-flash level.

TIP

When you finally get an interesting animal in your sights, don't skimp—shoot lots of frames. "Some people set the camera to shoot ten frames per second," says Michael Melford, "and then they go back and edit later. That increases your chances of getting that one frame in which the bird's wing is positioned just right. That's why I use a 16-gig card."

Manage and Share
Your Photos

9 | *Manage and Share Your Photos*

Previous pages:
Thanks to the digital
revolution, there are
more ways than ever
to share your images,
including via websites
and smart phones.

So far, this book has focused on shooting techniques and strategies. Now we look at how to manage all the great images that result from your new expertise.

JPEG VERSUS RAW

Nowadays, almost all professional photographers shoot in the raw format. *Traveler* and *National Geographic* magazines require it of assignment photographers. Raw files preserve all the data gathered by the camera's light sensor. Any adjustments made to the image data—whether in color, contrast, or exposure—are segregated as instructions in the file; they don't alter the original picture. In contrast, a JPEG file applies the adjustments permanently and also compresses the file, resulting in a loss of picture quality. "A JPEG has all your settings baked in," says *Traveler*'s Senior Photo Editor Dan Westergren. "With a raw file, you can always alter the recipe later and bake the picture a different way."

Raw files have to be converted in the computer for viewing, however, which is an extra chore. Westergren recommends you set the camera to shoot raw files and JPEGs simultaneously. "The JPEGs will be fine 80 percent of the time," he says. "For that other 20 percent of images, where the shooting settings may be wrong, having the raw files will allow you to go back later and tweak the pictures."

TRANSFER, RENAME, AND CAPTION

Traveler photographers are photojournalists. To them, gathering information about the subject and location is important. That includes getting names and contact information for anybody whose face is clearly shown in the picture. Collecting supporting information is a good practice for anyone hoping to get images published.

It used to be that caption information was submitted on paper. These days, it can be embedded as metadata in the picture files

TIP
You may need to use the raw conversion software that came with your camera to handle certain difficult exposures.

themselves. A software program popular with *Traveler* photographers is Photo Mechanic. It renames and attaches metadata, including captions, to your pictures as it "ingests" them from your media card onto your hard drive. You simply fill out a sheet of on-screen "stationery," and the information you enter is applied to all the images as they're imported. Afterward, you can select subsets of the images to apply more specific information to. So, you may have a group of 300 pictures labeled "San Ignacio Lagoon, Baja California, January 2010," with a subset of 50 pictures that have the additional tags of "gray whale" or "aboard the Linblad *Sea Lion*." This way, says Westergren, "you can fly through labeling a large group of pictures."

Social networking sites allow you to post galleries of your images for free to share with friends and family.

POST-PROCESSING

You've imported and tagged your raw files—perhaps on the road, using your laptop. Back home, use an image management program like Adobe Lightroom or Apple Aperture to batch-process your raw files on your main computer. Lightroom and Aperture, as well as the Adobe Camera Raw plug-in for Photoshop and Elements, allow you to make nondestructive batch enhancements

BACK UP YOUR COLLECTION

O nce you've transferred and corrected your files, don't let a house fire or faulty hard drive obliterate your work. Back it up.

"Today, storage is so cheap, there's no excuse not to do backup," says John Larish of Jonrel Imaging Consultants in Rochester, New York. "Terabyte [1,000-gigabyte] hard drives are now affordable [under $200]. I remember the first IBM one-gigabyte card, costing $1,000 each."

Make your backups automatic and redundant, Larish advises. "I store my photos three ways—on my computer's internal hard drive, on an external hard drive [above], and off premises. I also burn DVDs of my images. I guess that's four ways."

You can set up your Windows or Macintosh operating system to automatically back up selected files or folders to another drive on a schedule. Or, for better performance, choose a third-party software program. For online backup (immune to computer theft or house fires), choose a separate online service. Three reasonably priced (about $55 a year) choices are SOS Online Backup *(www.sosonlinebackup. com)*, Carbonite *(www.carbonite.com)*, and Mozy *(www.mozy.com)*. You choose which folders to back up. Set it up and forget about it.

Oh, except for the fact that (as Larish points out) you need to migrate your home backup files, over time, to the latest storage media, whatever they may be. "Remember Zip disks?" he says, referring to a storage product that was common in the late 1990s but is now all but obsolete.

to large groups of images, such as adjusting white balance, saturation, and contrast. After the adjustments are made, you can export the files as JPEGs or TIFFs (a higher-quality format) for sharing or having prints made. At that point, if necessary, you can make finer adjustments using image-editing software like Photoshop or Elements. Meanwhile, keep the original raw files in case you want to process them differently later.

MAKE PRINTS

No matter how many digital copies you have of your photo collection, make paper prints of your most prized images. Prints can last for decades, if not centuries. Photographer Lester Lefkowitz, who teaches courses at the International Center of Photography in New York City, recommends Epson printers loaded with DURABrite pigment inks. "But whatever brand of printer you choose," he says, "use the manufacturer's own paper and their best inks, listed on their websites. Don't mix paper and ink brands."

TIP
To share a large file without having it automatically compressed, upload it to Box.net and send a link to the file to your recipient.

The easier route is to let someone else do the printing. All three of the major online processing labs—Snapfish, Shutterfly, and Kodak Gallery—use long-lasting archival papers and inks. Or forget about prints and showcase your travel photos in a custom-published book. Use any of the three labs just mentioned, or design a coffee-table book at Blurb or Lulu, which allow you to sell your book to the public through their online stores.

SHARE YOUR IMAGES

"Your photos only ever come to life when somebody else sees them," says photographer Jim Richardson. "Share them." The digital age has made sharing easier than ever. Besides making prints or books, you can create audio slideshows, with voice-overs and music, and burn them to DVDs or post them on the Internet. Photographer Bob Krist has been experimenting with such multimedia projects, recording ambient sounds and interviews to go along with his photos. "It's 21st-century visual storytelling," he says.

Also share your photos on social networking sites, several of which focus on photography. These offer the chance to engage a community of serious and not-so-

serious shooters. Flickr *(www.flickr.com)* is the largest and most well known, and there are many others. *National Geographic* magazine has a site called My Shot *(ngm.nationalgeographic.com/myshot)*, where you can create your own photo page.

Photoshop *(www.photoshop.com)*, Picasa *(www.picasa. google.com)*,and other services also offer free online Web space for your pictures. Or put up your own site, as the pros do. Register a domain name at Network Solutions, or some other domain registry, which will also host your Web page for an extra fee. "It's easier than a lot of people think," says Will van Overbeek (whose own website is at *www.willvano.com*). "Once you get the page up, circulate the URL among people you know, and ask for their

feedback." Bob Krist has recently added a blog *(www. bobkrist.com/blog)* to his website. He hopes it will help attract customers to his stock photography business, and it helps him network with other photographers.

Ironically, social networking sites have made it harder for professionals to make a living off their stock images—but easier for amateurs to get noticed. Nowadays, magazines like *Traveler,* which use plenty of stock destination shots for short articles, may just as easily find usable photos on Flickr, popular with amateurs, as on the established stock agency websites, where professionals sell their work. "There's a huge oversupply of travel photos on the Web," Krist says. "Most of them are junk, but there are plenty of good ones, too."

The intersection of technique, savvy shooting strategies, and vibrant locations creates a striking photograph like this one in Montreal.

Useful Information

GENERAL PHOTOGRAPHIC INSPIRATION

Masters of Photography, www.masters-of-photography.com

Library of Congress, www.loc.gov/rr/print/catalog.html

International Center of Photography, www.icp.org

George Eastman House, www.eastmanhouse.org

Photomuse, www.photomuse.org

National Geographic Society photography, http://photography.nationalgeographic.com

PHOTOGRAPHY MAGAZINES

American Photo, www.popphoto.com

Camera Arts, www.cameraarts.com

Digital Photographer, http://digiphotomag.com

Nature Photographer, www.naturephotographermag.com

Outdoor Photographer, www.outdoorphotographer.com

PC Photo, www.pcphotomag.com

Photo District News, www.pdnonline.com

Photo Life, www.photolife.com

Popular Photography, www.popphoto.com

Shutterbug, www.shutterbug.com

PHOTOGRAPHY BOOK PUBLISHERS AND RETAILERS

Amazon, www.amazon.com

Aperture Foundation, www.aperture.org

National Geographic Books, www.nationalgeographic.com/books

Nazraeli, www.nazraeli.com

Phaidon, www.phaidon.com

photo-eye, www.photoeye.com

Twin Palms, www.twinpalms.com

STOCK AGENCIES

Aurora Photos, www.auroraphotos.com

Corbis, www.corbis.com

Getty Images, www.gettyimages.com

Magnum Photos, www.magnumphotos.com

VII, www.viiphoto.com

PHOTO SHARING SITES

Flickr, www.flickr.com

Photobucket, http://photobucket.com

Photo.net, www.photo.net

Photoshop.com, www.photoshop.com

SmugMug, www.smugmug.com

PHOTOGRAPHY HOW-TO AND ENTHUSIAST WEBSITES AND BLOGS

About, www.photography.about.com

Fred Miranda, www.fredmiranda.com

Luminous Landscape, www.luminous-landscape.com

Nikonians, www.nikonians.org

Online Photographer, http://theonlinephotographer.typepad.com

Photo Workshop, www.photoworkshop.com

Rob Galbraith Digital Photography Insights, www.robgalbraith.com

Robb Sheppard's Photodigitary, www.photodigitary.com

Strobist, www.strobist.blogspot.com

Take Great Pictures, www.takegreatpictures.com

EQUIPMENT REVIEWS

CNET, www.cnet.com

Digital Photography Review, www.dpreview.com

Imaging Resource, www.imaging-resource.com

SLR Gear, www.slrgear.com

Steve's Digicams, www.steves-digicams.com

WEBSITES OF SOME OF THE PHOTOGRAPHERS FEATURED IN THIS BOOK

Macduff Everton, www.macduffeverton.com, based in Santa Barbara, California, is known for his extraordinary panoramic photography.

Justin Guariglia, www.guariglia-chen.com, based in New York City, has shot extensively in the Orient.

Vince Heptig, www.heptig.com, based in Park City, Utah, specializes in outdoor adventure photography.

Aaron Huey, www.aaronhuey.com, based in Seattle, has broad experience in adventure and travel photography.

Catherine Karnow, www.catherinekarnow.com, based in San Francisco, known for her vibrant, sensitive style of photographing people, has shot frequently for *Traveler* and other national magazines.

Bob Krist, www.bobkrist.com, based in New Hope, Pa., is a top travel photographer who has written extensively on photographic technique.

Kris LeBoutillier, www.kriswerksphoto.com, based in Singapore, has shot for magazines, newspapers, and book publishers.

Pete McBride, www.petemcbride.com, based in Basalt, Colo., and specializing in travel and adventure, has shot on assignment in over 50 countries.

David McLain, www.davidmclain.com, based in North Yarmouth, Maine, often shoots for *National Geographic* magazine.

Michael Melford, www.michaelmelford.com, based in Mystic, Conn., shoots for magazines, ad agencies, design firms, and other clients.

Palani Mohan, www.palanimohan.com, based in Kuala Lumpur, Malaysia, has shot for newspapers and magazines and has published several photo books.

Richard Nowitz, www.nowitz.com, based in Rockville, Md., has shot on assignment for magazines, book publishers, and other clients, with travel one of his specialties

Chris Rainier, www.chrisrainier.com, based in Washington, D.C., has shot wild places and indigenous cultures around the world.

Jim Richardson, www.jimrichardsonphotography.com, based in Lindsborg, Kans., has shot dozens of assignments for *National Geographic* and *Traveler* magazines.

Will van Overbeek, www.willvano.com, based in Austin, Tex., has shot for numerous national magazines, including frequent assignments for *Traveler*.

CAMERA BAG ESSENTIALS

Camera bag
Camera body with neck strap and body cap
Plenty of memory cards and a case to
 hold them
Favorite lenses with lens caps
Lens hoods
Protective filters (UV, skylight)
Electronic flash unit (on-camera flash is
 not sufficient)
Air blower brush
Lens cleaner solution and tissue wipes
Tripod (alternatives are monopod,
 bean bags, clamps)
External flash unit
Extra batteries for camera and flash unit/charger
Reflector (an alternative to fill flash)
Cable release
Small flashlight
Power adaptors for traveling abroad
Silica gel packs for absorbing humidity in your
 camera bag.
Notebook and pens (a narrow "reporter's note-
 book" fits easily in a camera bag)

OPTIONAL EXTRAS

Second camera body (or point and shoot camera)
Other filters (polarizing, neutral density, graduated
 neutral density)
Card reader
Sensor cleaner
Laptop computer
Extra hard drives for backup
Small tarp for shooting in the rain
Small towel
Customized diopter to match your eyeglass
 prescription
Underwater housing
Pelican case (for dry storage)
Spirit level for shooting panoramas (fits on
 camera hot shoe)
GPS attachment (for geotagging your photos)
Digital voice recorder for taking audio notes
Compass, whistle

Index

PHOTO CREDITS:

2-3, Justin Guariglia/NationalGeographicStock.com; 4, Samantha Reinders; 6-7, Macduff Everton; 8-9, Aaron Huey; 11, David McLain/Aurora Photos; 12-13, Kris Leboutillier/NationalGeographicStock.com; 14, Kris LeBoutillier; 17, JEWEL SAMAD/AFP/Getty Images; 18, Jim Richardson; 20-21, Bob Krist; 23, Will Van Overbeek; 24, Kris LeBoutillier; 27 (UP), Bob Krist; 27 (LO), Bob Krist; 28-29, Justin Guariglia/NationalGeographicStock.com; 31, Jim Richardson; 32, Kris LeBoutillier; 34-35, Richard Nowitz/NationalGeographicStock.com; 37, Bob Krist; 38-39, Raymond Patrick Gonzales; 41, Jim Richardson; 43, Jim Richardson; 44, Raymond Patrick Gonzales; 46-47, Roland & Sabrina Michaud; 49, Jodi Cobb, NGS; 50, Jim Richardson; 53, Michael Melford/NationalGeographicStock.com; 54, Catherine Karnow; 57, Justin Guariglia/NationalGeographicStock.com; 58, Justin Guariglia/NationalGeographicStock.com; 61, Michael Melford/NationalGeographicStock.com; 63, Chris Rainier; 64-65, Peter McBride; 66-67, Catherine Karnow; 69, Kris LeBoutillier; 71, Macduff Everton; 72, Kris LeBoutillier; 75, Randy Olson; 76-77, Bob Krist; 79, Catherine Karnow; 80-81, Jim Richardson; 82-83, John Kernick; 85, Justin Guariglia; 86-87, Catherine Karnow; 88, Catherine Karnow; 90-91, Catherine Karnow; 93, Catherine Karnow; 95, Steve McCurry; 97, Catherine Karnow; 98, Justin Guariglia; 101, Catherine Karnow; 102, Justin Guariglia; 105, Justin Guariglia; 106-107, Catherine Karnow; 109, Catherine Karnow; 110, Kris LeBoutillier; 113, Kris LeBoutillier; 114, Catherine Karnow; 116-117, Aaron Huey; 119, Aaron Huey; 121, David McLain; 122-123, Macduff Everton; 124-125, Macduff Everton; 126, Catherine Karnow; 129, Palani Mohan; 130, Catherine Karnow; 133, Jim Richardson; 134, Kris LeBoutillier; 136-137, Michael Melford/NationalGeographicStock.com; 139, Peter McBride; 141, Vince Heptig; 142, Bob Krist; 145, Peter McBride; 146, Michael Melford/NationalGeographicStock.com; 148-149, Kevin Eans; 151, Kevin Eans; 152, Kevin Eans; 154-155, Will Van Overbeek.

ULTIMATE
FIELD GUIDE TO
TRAVEL
PHOTOGRAPHY

Scott S. Stuckey

Published by the National Geographic Society
John M. Fahey, Jr., President and Chief Executive Officer
Gilbert M. Grosvenor, Chairman of the Board
Tim T. Kelly, President, Global Media Group
John Q. Griffin, Executive Vice President; President, Publishing
Nina D. Hoffman, Executive Vice President;
 President, Book Publishing Group

Prepared by the Book Division
Barbara Brownell Grogan, Vice President and Editor in Chief
Marianne R. Koszorus, Director of Design
Carl Mehler, Director of Maps
R. Gary Colbert, Production Director
Jennifer A. Thornton, Managing Editor
Meredith C. Wilcox, Administrative Director, Illustrations

Staff for This Book
Kevin Eans, Project Editor and Illustrations Editor
Jennifer Seidel, Text Editor
Cameron Zotter, Designer
Bob Krist, Technical Consultant
Marshall Kiker, Illustrations Specialist
Lewis Bassford, Production Project Manager

Manufacturing and Quality Management
Christopher A. Liedel, Chief Financial Officer
Phillip L. Schlosser, Vice President
Chris Brown, Technical Director
Nicole Elliott, Manager
Rachel Faulise, Manager

The National Geographic Society is one of the world's largest nonprofit scientific and educational organizations. Founded in 1888 to "increase and diffuse geographic knowledge," the Society works to inspire people to care about the planet. It reaches more than 325 million people worldwide each month through its official journal, *National Geographic*, and other magazines; National Geographic Channel; television documentaries; music; radio; films; books; DVDs; maps; exhibitions; school publishing programs; interactive media; and merchandise. National Geographic has funded more than 9,000 scientific research, conservation and exploration projects and supports an education program combating geographic illiteracy. For more information, visit nationalgeographic.com.

For more information, please call 1-800-NGS LINE (647-5463) or write to the following address:

National Geographic Society
1145 17th Street N.W.
Washington, D.C. 20036-4688 U.S.A.

Visit us online at www.nationalgeographic.com

For information about special discounts for bulk purchases, please contact National Geographic Books Special Sales: ngspecsales@ngs.org

For rights or permissions inquiries, please contact National Geographic Books Subsidiary Rights: ngbookrights@ngs.org

Library of Congress Cataloging-in-Publication Data

Stuckey, Scott (Scott S.)
 Ultimate field guide to travel photography / Scott Stuckey.
 p. cm.
 Includes index.
 ISBN 978-1-4262-0516-3
 1. Travel photography. I. Title.
 TR790.S78 2010
 778.9'991--dc22

 2009034201

Printed in the U.S.A.

10/WOR/2